YEAR OF
PUBLIC
ART

Art in Chicago Neighborhoods

City of Chicago
Mayor Rahm Emanuel

CHICAGO DEPARTMENT OF
DCASE
CULTURAL AFFAIRS & SPECIAL EVENTS

YEAR OF PUBLIC ART

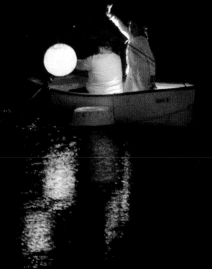

cityofchicago.org/dcase

Editor
Tricia Van Eck, 6018North

Co-editor
Iker Gil

Design
JNL graphic design

Photography
Ji Yang
Jasmine Clark
Additional photographers on page 245

Videography
Ji Yang

Cover, top:
Sam Kirk and Sandra Antongiorgi,
I Am Logan Square at
Kedzie Avenue and Milwaukee Avenue

Cover, bottom:
Sandra Antongiorgi, Andy Bellomo,
and Sam Kirk, *The Love I Vibrate*
at Howard Brown Health Center,
3245 North Halsted Street

Erica Mott Productions, *ELEMENTAL: Spectacles
of Earth, Air and Water* at Palmisano Park

The Year of Public Art catalogue was
made possible by the generous support
of Cari and Michael J. Sacks.

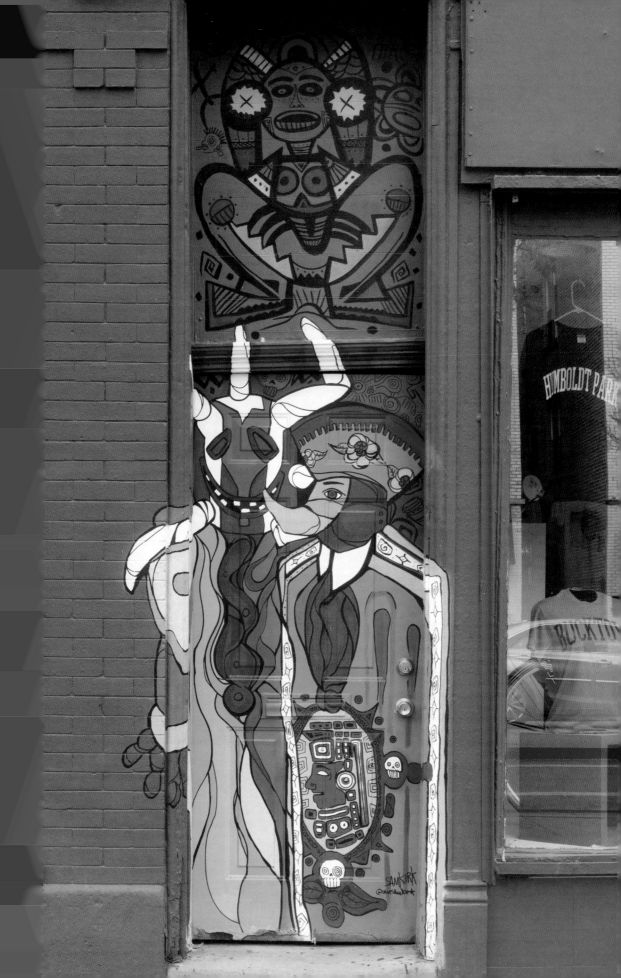

INTRODUCTIONS

50 YEARS OF HISTORY: INTERVIEWS AND TEXTS

50 WARDS OF ART: 50x50 NEIGHBORHOOD ARTS PROJECT

50x50: COMMUNITY ENGAGEMENT

ACKNOWLEDGEMENTS

INDEX OF ARTISTS' NAMES

Foreword

Whether painted on historic landmarks, covering train stations, accenting the Riverwalk, or enhancing viaducts, the lakefront, and parks across the city—public artwork is a critical part of Chicago's social fabric. As a result, Chicago's legacy as the vanguard of art, architecture, and design innovation is stronger than ever.

A major contributor to this growth is the participation of Chicago artists in the 2017 Year of Public Art and its *50x50 Neighborhood Arts Project*. The unprecedented, citywide effort to galvanize Chicago artists to realize a public art project brought sculptures, murals, mosaics, site-specific performances, and community-engaged work to all 50 wards.

As Mayor of Chicago, I am thrilled to celebrate these lasting, artistic contributions across the city. This book not only celebrates the scale and scope of the *50x50 Neighborhood Arts Project*; it highlights the creativity, connectivity, and character of each neighborhood.

We also honor the 50th anniversary of two of Chicago's most iconic public artworks: the Picasso in Daley Plaza and the Wall of Respect (which once stood at 43rd Street and Langley Avenue) on Chicago's South Side—world-renowned pieces that forever changed how artists and residents saw and gave meaning to art in public space.

A project of this magnitude could not have been realized without the important contributions of many key individuals. First and foremost, I extend our deepest appreciation to the talented artists who brought art into our parks, bus and 'L' stations, and across communities. My thanks also go to the Aldermen who initiated, prioritized, and funded world-class public art in their neighborhoods. I especially want to thank Cari and Michael J. Sacks, who understand that art is not just for downtown or museum enjoyment. Their generous donation made this catalogue and project possible. I am grateful for all they do for our city. Special thanks to Commissioner Mark Kelly and the Department of Cultural

Affairs and Special Events, who implemented this citywide undertaking and developed Chicago's Public Art Plan.

In Chicago, we have some of the most celebrated and extensive collections of publicly displayed civic artwork. The *50x50 Neighborhood Arts Project* helped to shine a spotlight on Chicago's legacy of public art, and to write the next chapter in our proud history of groundbreaking art, architecture, and design. It has paved a new way of connecting Chicago, while creating a model showcasing the impact cities can have when public art is prioritized as a public good.

It is safe to say that we would not be the world-class city we are today without this public art, created by Chicago's very own. I invite you to enjoy this collection, and visit the surprising, disruptive, inclusive art that is now woven into the rich tapestry of our social fabric.

Rahm Emanuel
Mayor, City of Chicago

Introduction

We are a city with incredible public art. Yes, it includes sculptures and monuments—but it's so much more. It's the city's creative spirit on display for everyone to view, to interact with, and to draw inspiration from. Art that invites you in—that encourages you to respond and to engage. As Commissioner of the Chicago Department of Cultural Affairs and Special Events (DCASE), I speak with great pride about all of the public artworks in our city, many that have brought Chicago renown and contributed to its legacy. Public art can help to build and reflect local pride. It also can spark dialogue and even controversy. But we know this. It's because it is out in the open and accessible, bringing joy and a creative buzz to the public realm.

Public art emerged as a recurring theme in conversations surrounding the Chicago Cultural Plan 2012, presented by Mayor Rahm Emanuel as the city's first plan for the arts since 1986. The Plan proposed that expanding art in public places could be a core strategy in elevating and expanding neighborhood cultural assets and a sense of place. With these goals in mind, DCASE began to formally solicit input from artists, cultural leaders, neighborhood advocates, and other citizens on the future of public art in Chicago. There was an emphasis on cooperation between City agencies and community leaders in planning public art projects. The resulting 2017 Year of Public Art galvanized our city in just this way, and the *50x50 Neighborhood Arts Project* was initiated—to enhance the quality of life throughout Chicago and to celebrate the legacy and future of Chicago's public art.

This book represents the Year of Public Art projects throughout the city and its *50x50 Neighborhood Arts Project*. It showcases collaborations between DCASE, the Chicago Department of Transportation, Chicago Park District, Chicago Public Library, and

Chicago Transit Authority, among others. It serves as an inspiration for what is next and is a direct product of Mayor Emanuel's Chicago Public Art Plan released during the Year of Public Art.

Chicago's Public Art Plan celebrates Chicago as a home for public art, while providing a path forward—establishing a shared vision for Chicago as a city where public art is valued and more essential than ever. It advocates for a diverse public art ecosystem and the nurturing of art that has the potential to surprise, inspire, challenge, and bring people together through shared experiences. And we saw it come to life in the Year of Public Art as artists worked alongside residents to bring compelling new works to every ward in our city.

I want to thank Mayor Rahm Emanuel for his steadfast commitment to public art; DCASE's Visual Arts and Public Art teams for their vision, dedication, and hard work on bringing these projects to our city; Tricia Van Eck, who managed and curated this Year of Public Art book, which highlights an impressive showcase of public art throughout the city; and the hundreds of artists and community partners and the Aldermen and governmental agencies who partnered with us on these initiatives. Thank you for bringing our vision to life—for celebrating and embracing public art as a defining feature of Chicago.

Mark Kelly
Commissioner, Department of Cultural Affairs and Special Events, City of Chicago

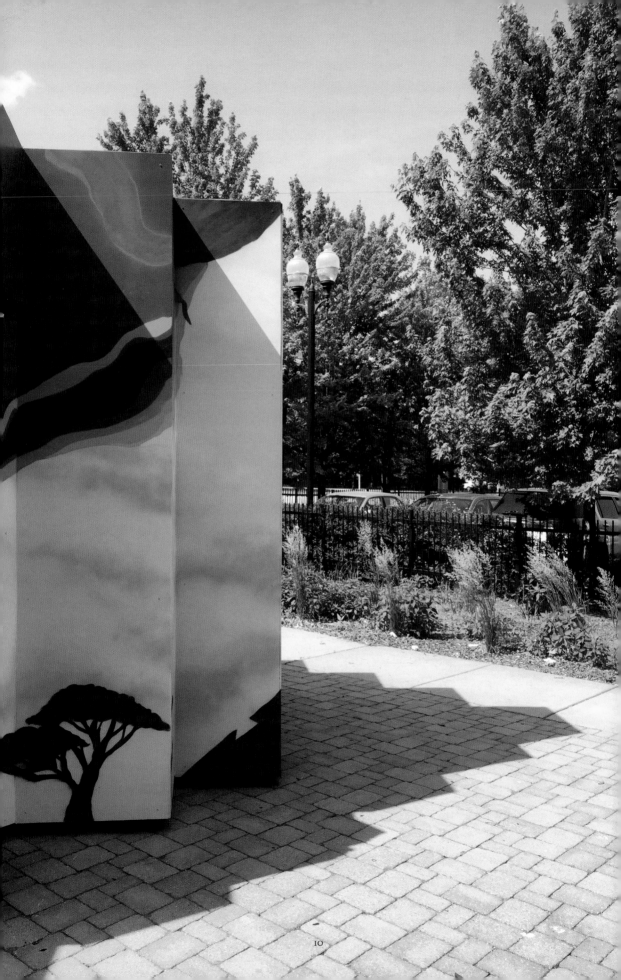

About This Book

This book is a guide to the 2017 Year of Public Art, which encompasses artworks throughout Chicago's 50 wards, commissioned via the *50x50 Neighborhood Arts Project* and in collaboration with Aldermen, community groups, creative organizations, and sister agencies across the city. Exploring connections between the past, present, and future of public art in Chicago, it includes a physical map of the completed public art projects and functions as a conceptual map of the terrain of public art across the city. It also works in tandem with Thyng, an app that allows the user to view in-the-moment footage of artists engaged in the creative process and of public celebrations during the Year of Public Art. The essays, interviews, and descriptions found in these pages provide insight into the creative intent and community engagement specific to the artworks created through the Year of Public Art.

Fifty Years of History

Interviews and Texts

Designated in 2017 by Mayor Rahm Emanuel, the Year of Public Art included a celebration of the 50th anniversary of the unveiling of the Chicago Picasso at Daley Plaza. Introduced by Mayor Emanuel, Commissioner Kelly, The Art Institute's Jacqueline Terrassa, University of Illinois's Lisa Lee, and National Museum of Mexican Art's Carlos Tortolero, the ceremony, called *Everyone's Picasso*, restaged the original 1967 unveiling of the sculpture. Conceived by artist and historian Paul Durica, it included readings and performances by Nora Blakely, Orbert Davis, Tatsu Aoki, Avery R. Young, Chicago Children's Choir, and the After School Matters Orchestra, as well as a conceptual re-unveiling of the Picasso by Edra Soto. Passing out handheld fans with designs inspired by Spain, Picasso's country of origin, Soto asked the audience to hold up their fans and imagine what life would be like without the Picasso and public art.

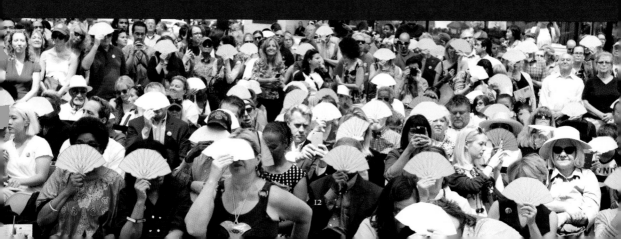

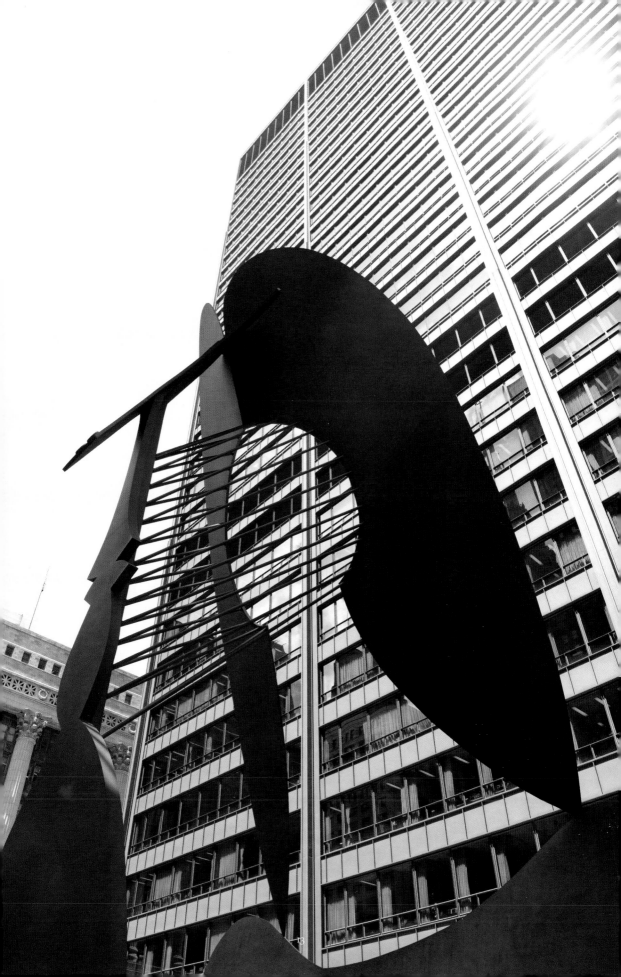

The Picasso

Eric Keune

On August 15, 1967, approximately 50,000 people gathered at 50 West Washington Street in downtown Chicago for the unveiling of Picasso's untitled sculpture. The event included a performance by the Chicago Symphony Orchestra and a series of speeches, including the reading of a message from President Lyndon B. Johnson. Pulitzer Prize-winning poet Gwendolyn Brooks wrote and read a poem commissioned for the occasion. After much anticipation, Mayor Richard J. Daley and William Hartmann, former managing partner at Skidmore, Owings & Merrill (SOM), pulled a rope to release the fabric shroud, revealing the full-sized abstract work to the audience.

In this text, Eric Keune, design director in SOM's Chicago office, discusses how the Picasso sculpture came to be, SOM's role in the process, and the relevance of the sculpture five decades after its unveiling.

The sculpture was a late arrival in the process of the design of the Chicago Civic Center—now the Richard J. Daley Center—which was jointly designed by architecture firms C.F. Murphy Associates, SOM, and Loebl Schlossman Bennett & Dart. Jacques Brownson, from C.F. Murphy, was the lead designer for the project. From the outset there was an aspiration to place a monumental work of sculpture on the plaza, but no consensus was ever reached. As the design was nearing completion, the group realized that they needed to refocus their attention on the selection of a suitable art piece. The group members, including designers from the three firms, each individually put forward a list of names of world-renowned artists. They voted unanimously for Pablo Picasso. William Hartmann then proposed Picasso to Mayor Richard J. Daley, who agreed with the choice stating that "if he was the best artist in the world, he would be good for Chicago." Although Picasso was the chosen artist, nobody personally knew or had a direct connection to him. After contacting his gallerist in Paris, Picasso expressed his interest in the project.

William Hartmann and a small team flew to France to meet with Picasso, then in his 80s, to discuss the project. While Picasso was a world-renowned artist, he had surprisingly never undertaken a monumental public sculpture before. Hartmann and the team continually courted Picasso over an extended period to convince him to take on the project. The group brought with them a package of semi-arcane objects and gifts meant to entice, piquing his interest with baseballs, hats, jerseys; hockey sticks and pucks; Native American headdresses; a conductor's baton; recordings of the Chicago Symphony Orchestra and the Lyric Opera of Chicago. In a way, they were creating a time capsule of Chicago—

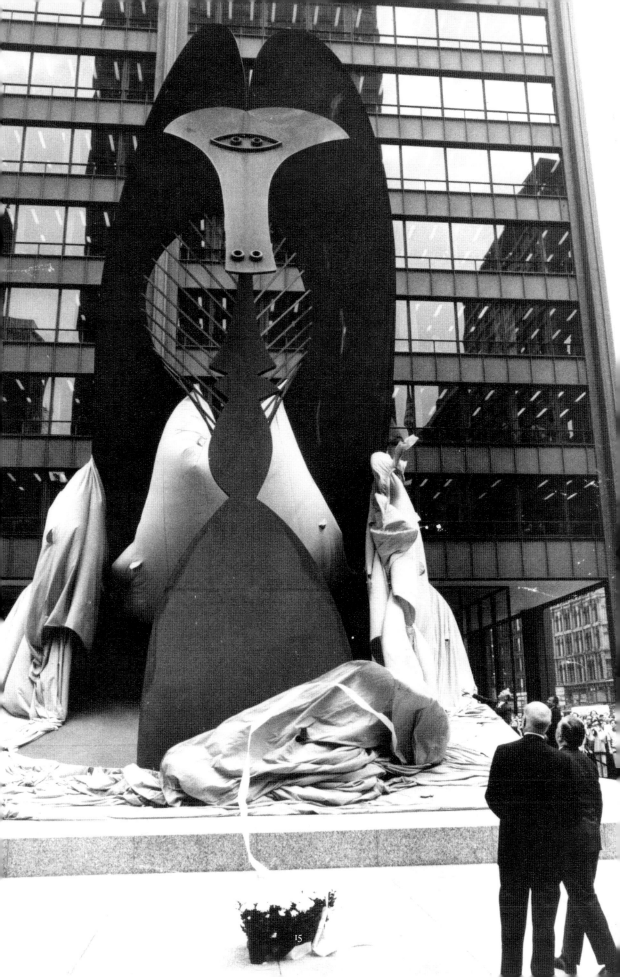

knowing that Picasso had never visited the city, and in all likelihood never would—hoping that something would stick. The plan worked. The group brought with them photographs of the building design models and related drawings, and since the building was under construction, they brought photographs to give Picasso a sense of the scale of both the space and the sculpture that he was being asked to design. Everyone felt that 50 feet was the right height, but this was ultimately up to Picasso to decide.

During one of the trips to France, Hartmann brought up the question of payment. Hartmann was prepared to write a blank check, for potentially any amount. When he asked Picasso how much, Picasso refused the payment, stating that it was his gift to the citizens of Chicago in gratitude for having been considered. The group continued to send "care packages" as the process moved forward. Two years later, in May of 1965, Picasso contacted Hartmann to indicate he was ready to share two 42-inch-tall maquettes that he had produced in his studio. Both were made of sheet metal, cut with shears, and lightly soldered or tack-welded together. One was made of heavier gauge metal with thicker rods and pipes, while the other was lighter and more delicate. Hartmann travelled to France and, with Picasso's input, the two ultimately chose the lighter option. It was this model that was crated up and hand-carried back to Chicago. Upon its arrival, the model was approved by Mayor Daley and the Public Building Commission.

Hartmann asked Bruce Graham, design partner at SOM, to identify a person who could translate the maquette into a 50-foot-tall sculpture. Graham selected Fred Lo, a young design architect and later associate partner in the firm, who was working on the Civic Center project. Lo's task was to convert the three-dimensional, relatively crudely made artifact into orthographic plans, sections, and elevations. As this work was to be conducted largely outside of the public eye, he worked in a room in the basement of the Art Institute of Chicago after office hours. He created, in essence, a Renaissance perspective box—a three-sided enclosure with regular grids inscribed on all sides—which he used to accurately locate points in space and devise the orthographic drawings. Lo then worked with Joe Colaco, a structural engineer at SOM, to transform the small sculpture into a structurally viable 50-foot-tall monument. At this moment the design underwent a potentially highly polarizing and controversial metamorphosis. The engineering process revealed that the suggested sizes and thicknesses of the main structural members would not be sufficient to support the sculpture in its larger scale, nor to reinforce it for the additional loading imposed by Chicago's strong winds. This led Lo and Colaco, working in collaboration, to introduce a few strategic and carefully located modifications to Picasso's original design. Hartmann felt that the proposed changes were an affront to the work of a visionary artist. The team argued that, without the changes, the sculpture would not survive a 100-year wind event, and that both a vertical stiffener plate and a ring-like collar located on the underside of the two "wings" had to be added. Despite his dissatisfaction with the changes, Hartmann took a model that the team made reflecting the modifications to meet Picasso in France. After reviewing the

sculpture for several days, Picasso approved it, allegedly having said, "It actually looks better than the original."

From this point a series of maquettes were made that progressively doubled in size: first in wood, then in plywood at quarter-scale, and then at half-scale out of metal. The team would carefully photograph every iteration and send the images to Picasso, ensuring that he reviewed and approved the design evolution at each step.

The American Bridge Division of US Steel in Gary, Indiana, was chosen to fabricate and install the sculpture in Chicago. Corten steel, at the time a new material, was selected for its strength and because it didn't require any maintenance. The Civic Center, which uses the same material for its façade, was only the second building ever to be made of Corten, following Eero Saarinen's John Deere World Headquarters (1964) in Moline, Illinois. It was somewhat unusual for a work of art at this scale to utilize the same material as the building.

The 50-foot-tall, 160-ton sculpture was erected between May and August of 1967 in the plaza, behind fencing, so the public could not see it. On the day of the unveiling, August 15, 1967, it was completely shrouded in a white sheet. When Mayor Richard J. Daley and William Hartmann both pulled the rope, the curtain fell, and the sculpture was revealed to the world for the first time at full scale. There were thousands of people in the plaza who initially received it with both acclaim and criticism. Since the unveiling of the sculpture, trickling off sometime into the mid- to late-1970s, SOM continually received letters (mostly of complaint) from people who didn't like it. The letters were sent to City Hall, who promptly forwarded them to SOM. The office today has an extensive archive of grievance letters from Chicagoans not in favor of the sculpture. Among them are scattered a few letters of support—commendable that members of the public would have written the Mayor's office and the City to show both their appreciation for the work and the courage required to achieve it.◆

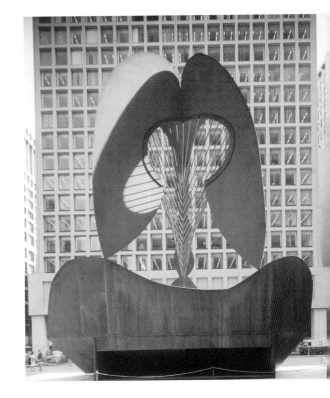

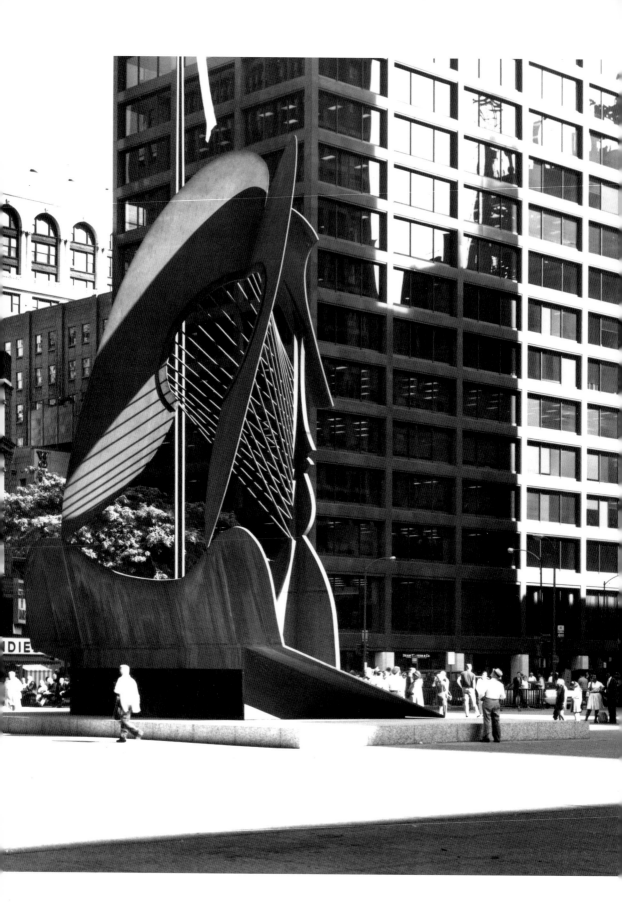

THE MONUMENTAL SCULPTURE PORTRAYED BY THE MAQUETTE PICTURED ABOVE HAS BEEN EXPRESSLY CREATED BY ME, PABLO PICASSO, FOR INSTALLA-

TION ON THE PLAZA OF THE CIVIC CENTER IN THE CITY OF CHICAGO, STATE OF ILLINOIS, UNITED STATES OF AMERICA. THIS SCULPTURE WAS UNDER-

TAKEN BY ME FOR THE PUBLIC BUILDING COMMISSION OF CHICAGO AT THE REQUEST OF WILLIAM E. HARTMANN, ACTING ON BEHALF OF THE CHICAGO

CIVIC CENTER ARCHITECTS. I HEREBY GIVE THIS WORK AND THE RIGHT TO REPRODUCE IT TO THE PUBLIC BUILDING COMMISSION, AND I GIVE THE MAQUETTE

TO THE ART INSTITUTE OF CHICAGO, DESIRING THAT THESE GIFTS SHALL, THROUGH THEM, BELONG TO THE PEOPLE OF CHICAGO.

LA SCULPTURE MONUMENTALE REPRÉSENTÉE DANS LA MAQUETTE MONTRÉE CI-DESSUS FUT CRÉÉE PAR MOI, PABLO PICASSO, EXPRESSÉMENT POUR ÊTRE

INSTALLÉE DANS LA PLACE DU CENTRE CIVIQUE DE LA VILLE DE CHICAGO, ETAT D'ILLINOIS, ETATS-UNIS D'AMÉRIQUE. CETTE SCULPTURE FUT ENTREPRISE

PAR MOI POUR LA COMMISSION DES EDIFICES PUBLICS DE CHICAGO À L'INSTANCE DE WILLIAM E. HARTMANN, AGISSANT AU NOM DES ARCHITECTES DU

CENTRE CIVIQUE DE CHICAGO. PAR CES PRÉSENTES JE FAIS DON DE CETTE OEUVRE ET DES DROITS DE LA REPRODUIRE À LA COMMISSION DES EDIFICES

PUBLICS, ET JE DONNE LA MAQUETTE À L'INSTITUT D'ART DE CHICAGO, DANS LE DÉSIR QUE CES DONS, PAR LEUR INTERMÉDIAIRE, PUISSENT APPARTENIR

AUX CITOYENS DE LA VILLE DE CHICAGO.

SIGNED AT *Mougins A.M* THE *21* DAY OF *Aout* 1966.
SIGNÉ À *France* LE JOUR DE

Picasso

PABLO PICASSO

WITNESSES:
TÉMOINS:

The Wall
of Respect

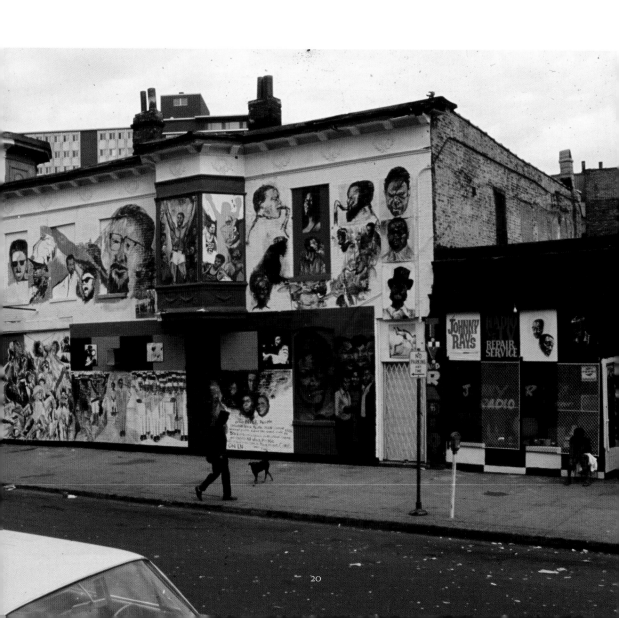

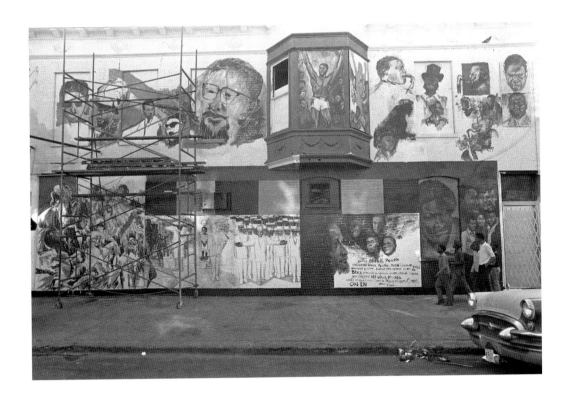

The Wall of Respect, a 1967 public mural, painted on the side of a building at 43rd Street and Langley Avenue, depicted black heroes and heroines in the areas of music, art, literature, politics, and sports, ranging from Sarah Vaughan and John Coltrane to Marcus Garvey and Ossie Davis. Destroyed after a 1971 fire, today no sign indicates it existed. However, it received national critical acclaim when it was unveiled following the 1963 March on Washington and the 1965 assassination of Malcolm X, and in the midst of the emergence of the Black Power movement. The wall sparked a nationwide mural movement, foregrounded community engagement, and is a seminal work of the Black Arts Movement. The 2017 exhibition, *The Wall of Respect: Vestiges, Shards and the Legacy of Black Power*, at the Chicago's Cultural Center, chronicled how the Organization of Black American Culture's (OBAC) Visual Artists Workshop designed and produced the mural. The curators of the exhibition, Romi Crawford, Abdul Alkalimat, and Rebecca Zorach, reflect on the project in the following essays.

Wall of Respect Reminiscences

Rebecca Zorach, Abdul Alkalimat, and Romi Crawford

Rebecca Zorach

It was an honor to have the opportunity to research, write, and edit material for the book *The Wall of Respect: Public Art and Black Liberation in 1960s Chicago,* and to work on the related exhibition at the Chicago Cultural Center. In large part it was the opportunity to work with Abdul Alkalimat and Romi Crawford that made the experience so amazing. But I'd like to highlight an additional aspect of this process that made it especially meaningful. At every step in the process of researching and writing about the Wall of Respect, from working with a group attempting to commemorate the Wall's 50th anniversary, to organizing (with Drea Howenstein) a single panel discussion, to helping organize (again with Drea) a symposium at the School of the Art Institute of Chicago, I have had the good fortune to learn something new. Putting research out into the world invariably brings opportunities for new insights that I wish I'd had before, and this was especially true of this project. This is also to say that although we tried to be quite comprehensive with the Wall of Respect, there are things we didn't include, couldn't include, or only learned about later. There are the photos of Muhammad Ali visiting his portrait on the Wall that had been auctioned off before we started. There were photos of the Wall of Respect and the Wall of Truth (located across the street from Wall of Respect) that came to me via a curator who received an anonymous donation that didn't fit within the scope of her institution (and which present new information about panels that were part of the Wall of Truth in particular—images I'd never seen). There were negatives from an unknown newspaper photographer showing Jeff Donaldson's portrait of Nina Simone *before* a neighbor asked him to change it. There was the realization that in some of Darryl Cowherd's photos of the neighborhood young people holding the banner reading *Full Support for Black Liberation,* Eugene "Eda" Wade can be seen in the background making his fateful changes. And finally, there's the remarkable phone call I received from Ziff Sistrunk, who as a boy was one of the many children who hung out around the Wall—in fact, he was one of the children who offered to give tours to visitors for a quarter, and even painted on the Wall of Truth. Ziff was able to identify many of the other children and some of the adults involved, and to provide stories about what went on before, during, and after what was a major event in his young life. In the future, I hope we'll continue to learn more details, not just about the artists who made the Wall and the figures portrayed on it, but about the local community that lived with the Wall in their everyday life on the block.◆

Abdul Alkalimat

One continues to learn how important history is, and the 50th anniversary of the Wall of Respect brought this home to me in deeply subjective ways. Of course, there is the big picture of Black art and culture in Chicago that we covered in our book on the Wall, but it was a very intense personal experience as well. Diving back into the late 1960s forced me to realize that to understand history it is necessary to confront what was then and not impose what is now. We were grappling with the Fanonian dialectic of moving from fighting our way into the mainstream as integrationists, to Black consciousness and the affirmation of Black culture in search of Black unity. I was working on a degree inside the system at the University of Chicago while at the same time serving as an ideologist within the autonomous organization OBAC leading to the Wall. Moreover, I was one of the youngest activists and learned more than I led. This realization negates the memory duped by ego. But most important of all is that the rediscovery of historical memory leads one back to personal relationships, both with those who have made their life transition and those who live on as you do. I miss Jeff Donaldson, Amus Mor, and most recently Bobby Sengstacke. My experiences with them took me to places known only to the deepest depths of our Black tradition of proclaiming that truth, beauty, and freedom are possible. And the photographers. They taught us to see ourselves, therefore making it possible, even giving us the permission to be ourselves. Rapping again with Roy Lewis and Darryl Cowherd has been rewarding and a challenge to see that from there we got to where each of us currently moves. I remember Hoyt Fuller, both how he embraced me and gave me access to myself as a writer in the pages of Negro Digest/Black World. Sterling Plumpp continues to be a link for me back into those days, and remains an example of the absolute brilliance that blessed so many of us in those great days of the 1960s. We hear about walls being built today to keep people out of something, but the Wall of Respect was different. The Wall of Respect was an invitation into something, a gateway to self-affirmation and bold opposition to racist representation. And, as is always the case, after writing up what we thought we knew about history new information comes forward that helps us see what we didn't know. The recent novel by Walter Mosley, *John Woman*, hits the nail on the head about history, especially the ideological debates that surrounded the Wall and the Black Arts Movement in general: "Our lives are just one long series of ad hoc debates. In the end everybody loses the argument." I say this not because we were all wrong, but that all of us had a bit of the truth, just not all of it.◆

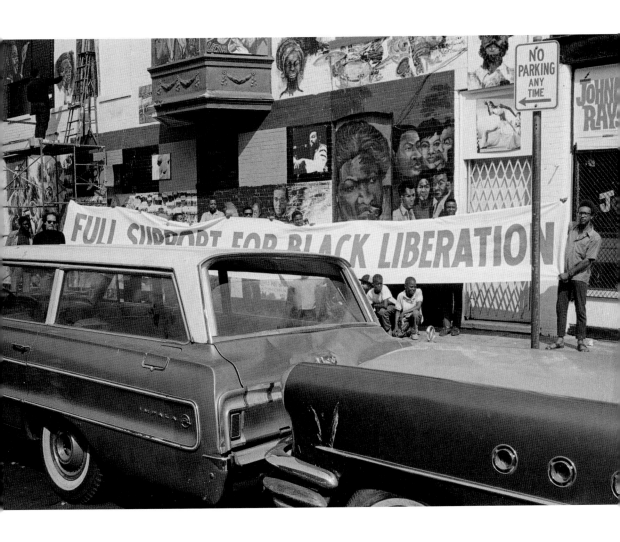

Romi Crawford

The Wall of Respect was a humble work. Gwendolyn Brooks's poem, "The Wall," written for its dedication, evokes this— "A drumdrumdrum. Humbly we come." It emerged in 1967 out of the steadfast will and committed energies of an ensemble (of artists, scholars, activists, and community members) that needed it and wanted it, rather than the force of a single inventor/author. Yes, the content of the Wall of Respect included heroes and "sheroes," and it was indeed a bold, brave instantiation and affirmation of black culture and pride, but in another sense the makers were not constrained by, nor hung up on, notions of the heroic.

While the Wall of Respect is wholly worthy of the praise and attention that it receives at the moment—a notable presence in the recent *Never a Lovely So Real* exhibit at the Art Institute of Chicago and the *Soul of a Nation* exhibit that traveled from the Tate Modern in London to museums in the US, as well as being a topic of discussion in documentaries, academic convenings, symposia, and college courses—it was not made in the spirit of producing a monumental or heroic masterwork. Instead the Wall of Respect defied norms and expectations of permanence and laudability. How so? (1) It was as unassured as it was assured, edited and revised various times. (2) It was not protected by museum walls or guards, yielding to climatic and social shifts. (3) It was not formally overproduced, but made quickly from concept to finish in the span of a few months (on *colored people's* time if you will, which contrary to popular belief can be as fast, quick, and efficient, as it can mosey).

Our book on the Wall of Respect, published in 2017, the year that would have marked its 50th anniversary if it had existed longer than five years, helped shed new light on it. Yet, in the end it instigated as many questions as it offered answers. One of the most pressing questions for me during the research phase, and even more so now, stems from the Wall's noteworthy impermanence and how this simultaneously aligns and misaligns with the need for an ongoing appreciation of it. Or, how can we remain aware of and present to the Wall of Respect even in its absence and in ways that actively absorb some of the methods of impermanence and improvisation learned from the case of the Wall?

A project called *Fleeting Monuments for the Wall of Respect* has spun from this question.

It is comprised of contributions by artists (Damon Locks, Stefano Harney and Fred Moten, Faheem Majeed, the Amus Mor Project, Naeem Mohaiemen, Cauleen Smith, Kelly Lloyd, Norman Teague, and Bethany Collins, among others) whom I asked to consider how the Wall might be remembered through acts, gestures, practices, etc., that are not monumentalizing. For *Fleeting Monuments* I encouraged them to work from a prompt influenced by the methods of improvisation cued in the making of the Wall of Respect.

Reasserting the epistemologies embedded in the Wall of Respect has been my focus the past year. The Wall of Respect is laden with information, some of which we gathered for the book and some outstanding. But in addition to the names, dates, and images about the Wall of Respect, there are also significant methodologies to probe further. These offer direction for how we might do something equally risk-taking in this present time. These projects—*Fleeting Monuments for the Wall of Respect*; *Art Moves: Chicago's Innovative Structures of Address*, a project based on grassroots models from the 1960s and 70s for circulating information about black art to residents on the South Side of Chicago; and the Museum of Vernacular Arts and Knowledge, an organization I recently founded to undertake projects which highlight the significance of art and knowledge forms not within the purview of art museums and galleries because they are out of sync with dominant social, political, aesthetic, and institutional values—follow from and are influenced by the deep structural knowledge forms inherited from the Wall of Respect.◆

50 Wards of Art

50x50 Neighborhood Arts Project

50x50 ARTWORKS IN THE WARDS OF THE CITY OF CHICAGO

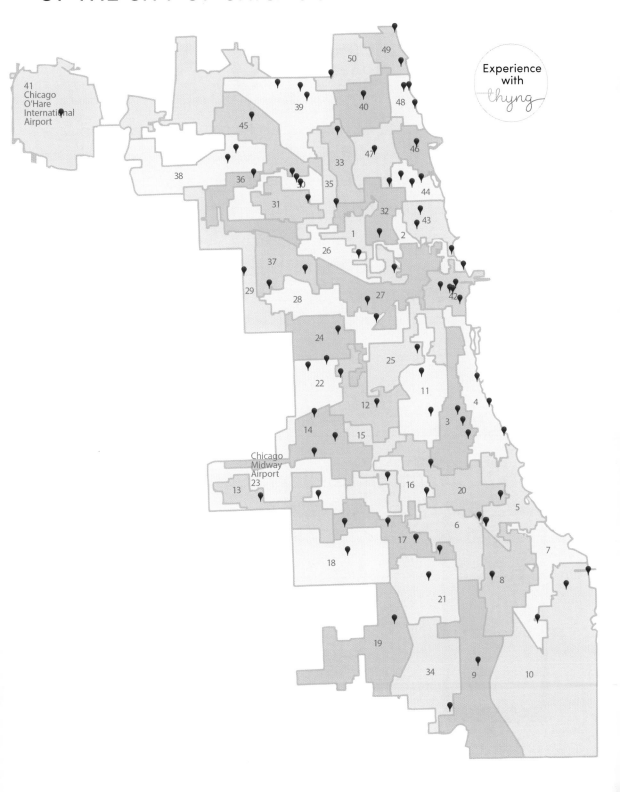

Experience with *thyng*

41
Chicago
O'Hare
International
Airport

50 49

39 40 48

45 47 46

38 36 33 35 44

31 32 43

1 2

26

37 28 27 42

29

24 25

22 11 4

12 3

14 15 5

Chicago
Midway
Airport
23 16 20

13 17 6 7

18 8

21

19

34 9 10

How to Use the Thyng App

The Thyng app, developed at 1871, a Chicago-based technological incubator, links the works of art found in these pages to the future of art and technology. To bring the artists' pages to life on your phone, go to the app store, and download the Thyng app for free.

Select "Targets" mode, then scan pages with the the Thyng icon to view "in the moment" video footage of artists and communities engaged in creative work and celebratory moments during the Year of Public Art.

DOWNLOAD THYNG APP

SCAN PAGES IN "TARGETS" MODE

EXPERIENCE AUGMENTED REALITY (AR)

Miguel A. Del Real

Abrazando La Vida / Embracing Life

Mural

The Chicago Department of Family and Support Services, 1615 West Chicago Avenue

Using positive symbolism and bold colors, Miguel Del Real's mural radiates a meditative energy while functioning as a reminder to balance our mind, matter, and soul. The central images—of the earth goddess, the lotus flower, and the pinecone/pineal gland—symbolize heightened awareness. A vibrant hummingbird with wings enveloping the goddess's nurturing hand conveys interconnection and community. Anchoring the entire composition is an overflowing cornucopia modeled on a golden ratio spiral, illustrating abundance.

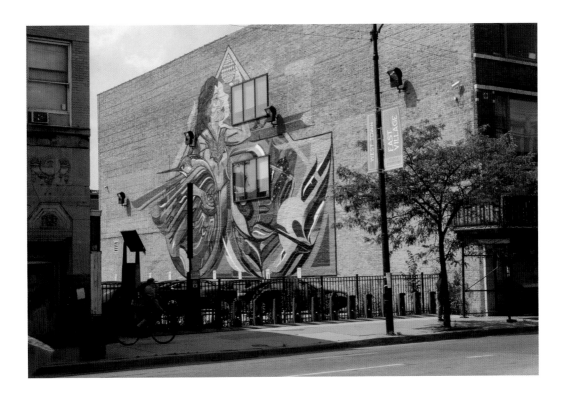

Erik DeBat

The Heart Project
Mural
Chicago Avenue at Lakeshore Path

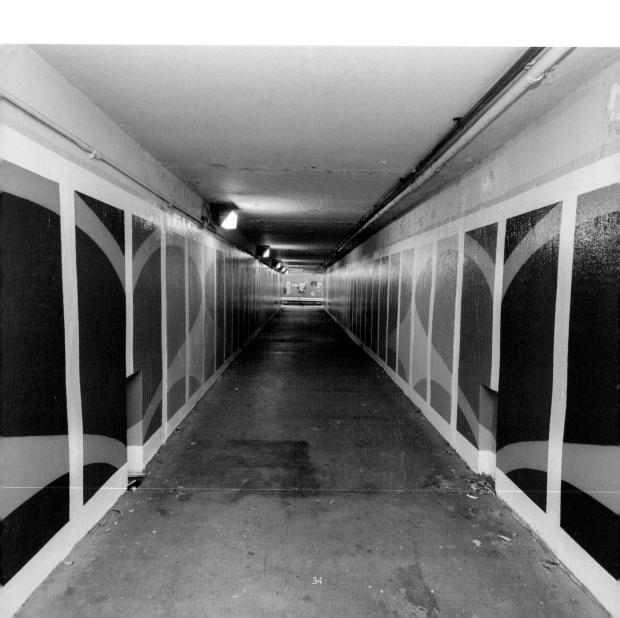

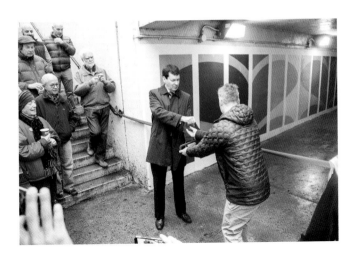

The Heart Project is a 320-foot-long mural installation within the viaduct that links Streeterville to Lake Michigan. The mural's vertical stripes recall a row of window panes. Each stripe is colored differently, forming a spectrum of cool and warm tones along the passageway.

Experience with *thyng*

Olusola "Shala." Akintunde

Shala's Bronzeville Solar Pyramid
Sculpture
Gallery Guichard, 436 East 47th Street

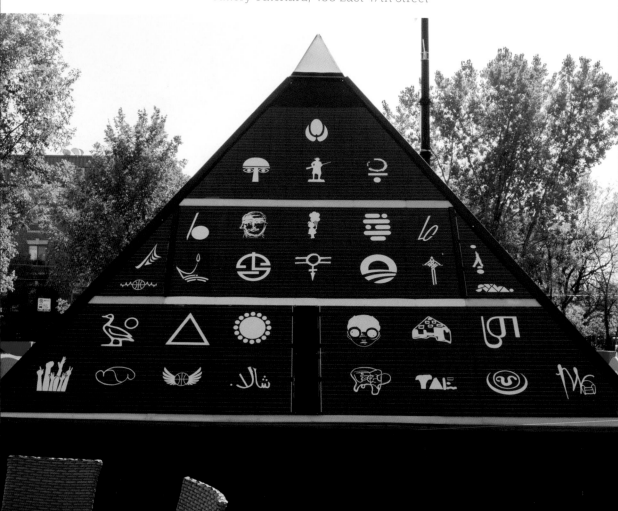

Shala's *Solar Pyramid* generates solar energy and shines through a system of hieroglyphics Shala created with ComEd's Solar Spotlight Program, which exposes high school students to renewable energy and STEM—science, technology, engineering, and math. Local students created the hieroglyphics to represent images of themselves, their neighborhood, Bronzeville, and Chicago.

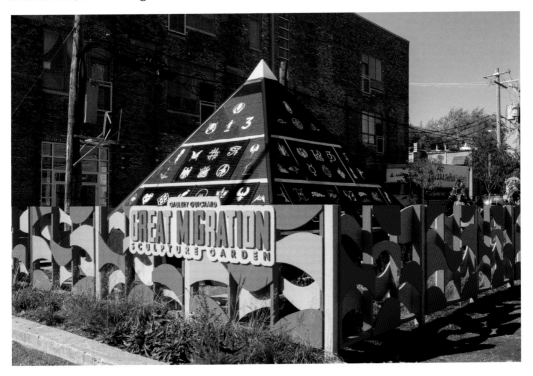

Tonika Johnson

Boys in Water
Laying of Hands
Grow Radiant
Barbershop I
Lightboxes
Chicago Transit Authority, Indiana Green Line Station, 4003 South Indiana Avenue

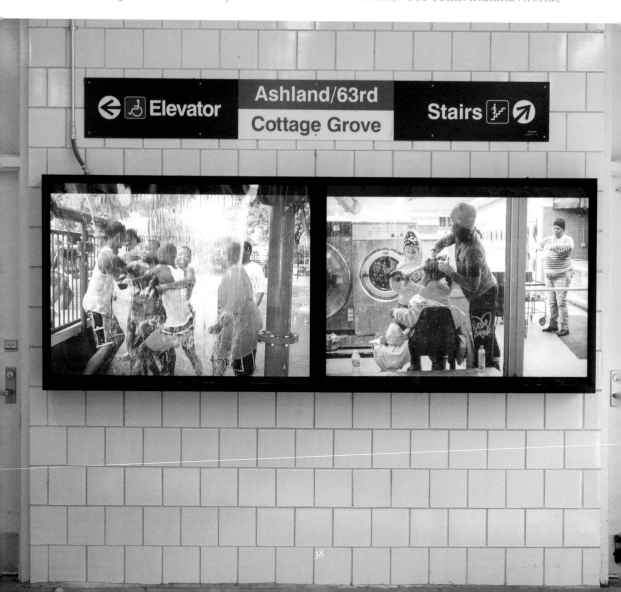

Alderman Pat Dowell

Tonika Johnson, a resident of the Englewood neighborhood, seeks through her photographs to challenge negative perceptions of Englewood as a dangerous and poverty-plagued community. By capturing images of happiness and normalcy, she presents an "insider" perspective that counteracts stereotypes.

During the Year of Public Art, the Chicago Transit Authority (CTA) partnered with DCASE to create the CTA Lightbox Art Project, with lightbox installations in train stations, highlighting the perspectives of Chicago artists and neighborhoods. *Grow Radiant* was also included in the Chicago Cultural Center's 2017 exhibition *50x50 Invitational / The Subject is Chicago: People, Places, Possibilities*, which presented the work of one artist from each of Chicago's 50 wards.

Left lightbox: *Boys in Water*
Right lightbox: *Laying of Hands*

Grow Radiant

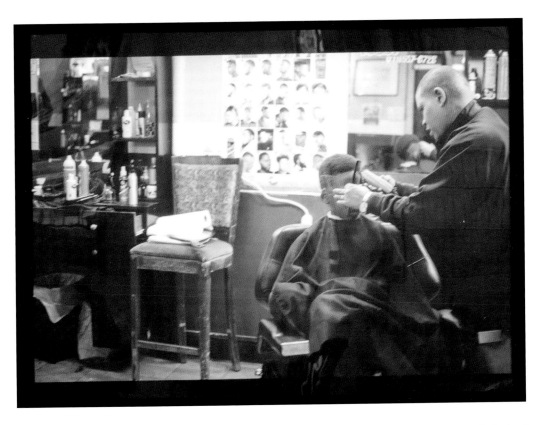

Barbershop I

Clifton Henry

Standing Room Only
Havana Blues
Lightboxes
Chicago Transit Authority, 43rd Street Green Line Station, 314 East 43rd Street

Standing Room Only

Clifton Henry describes his photographs as film stills, with an evolving narrative compiled from personal experience, social concerns, and life struggles. Influenced by imagery from the Civil Rights Movement and the Harlem Renaissance as well as the work of visual storytellers Gordon Parks and Norman Rockwell, he intends his images to empower and inspire. The photographs displayed at the station are from a trip he took to Havana, Cuba.

Havana Blues

Architreasures
with Bernard Williams

Letter to Bessie Coleman
Sculpture
Chicago Park District, Burnham Park at 39th Street Beach

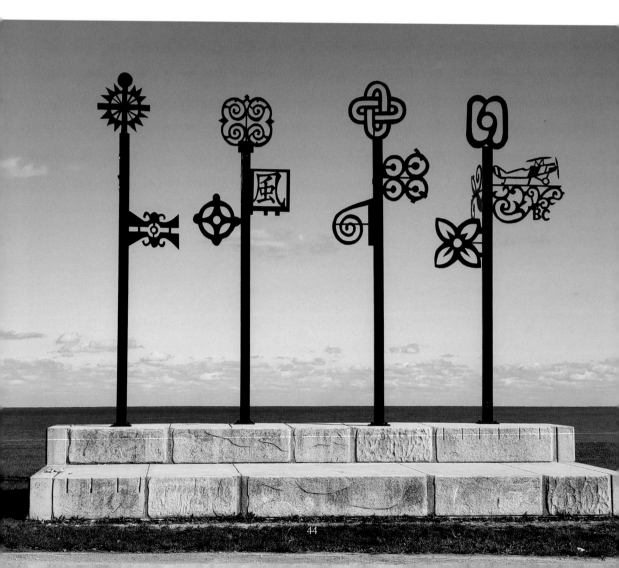

Created by Bernard Williams in collaboration with Architreasures, an art-based community development organization, this painted steel sculpture honors Bessie Coleman, the first woman of African American and Native American descent to become a licensed aviator.

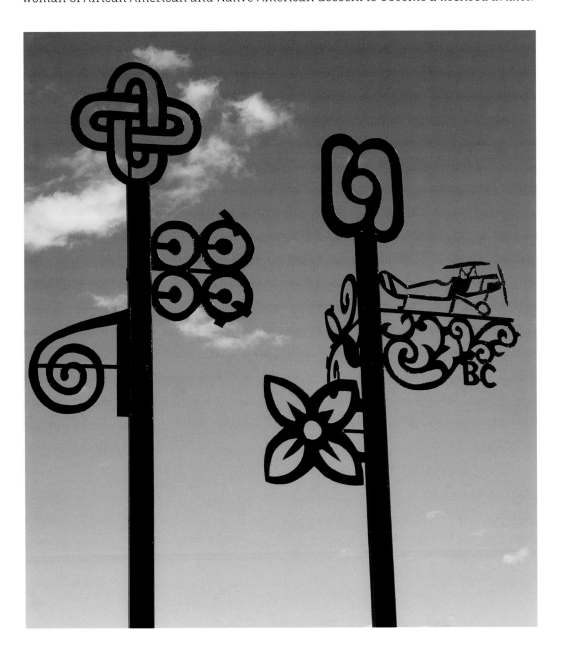

Jenny
Kendler

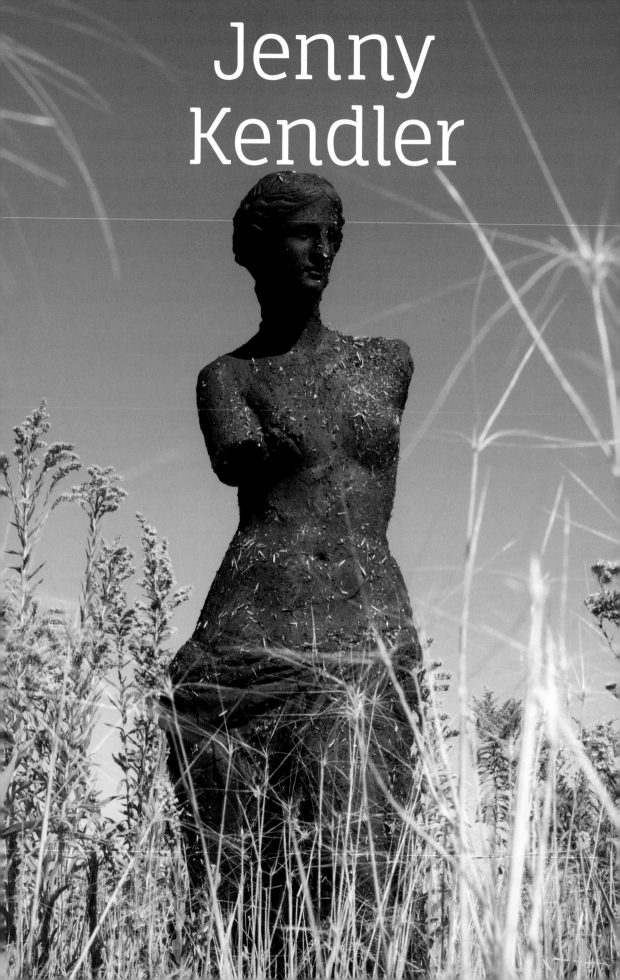

WARD 4

Alderman Sophia King

Sculpture→Garden
Sculptural installations
Chicago Park District, various locations:

Venus I, II & III
Burnham Wildlife Corridor,
south of 31st Street Beach
Winter solstice, December 2017

Venus VII, VIII & IX
Burnham Wildlife Corridor,
north of 47th Street
Summer solstice, June 2017

Venus IV, V & VI
Steelworkers Park, 87th Street
at Lake Michigan
Vernal equinox, March 2017

Venus X, XI & XII
Burnham Wildlife Corridor,
south of 31st Street Beach
Autumnal equinox, September 2017

On each solstice and equinox in 2017, Jenny Kendler installed a set of biodegradable sculptures in a natural area within a park. *Sculpture→Garden* draws from classical Greco-Roman sculpture, filtered through vernacular American garden statuary. Hellenic sculptures used the human body as a symbol for heavenly perfection and immortal beauty, epitomized in the Venus de Milo, a representation of the goddess of love. In *Sculpture→Garden* , the Venus is replicated in soil and biodegradable binders, suffused with native prairie plant seeds. Over time, the idealized form biodegrades and becomes more of a "real" body, weathering while dispersing seeds for future gardens. *Venus IV, V & VI* were installed in Ward 10.

In 2017, the Chicago Park District installed 52 new works of public art in more than 40 parks across the city, some of which were part of the *50x50 Neighborhood Arts Project*.

At left: *Venus XII*

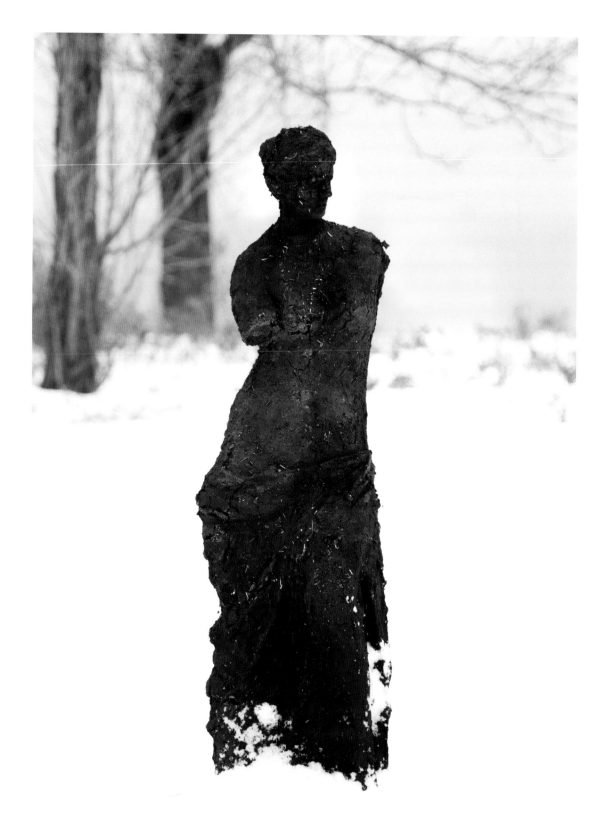

Venus XII

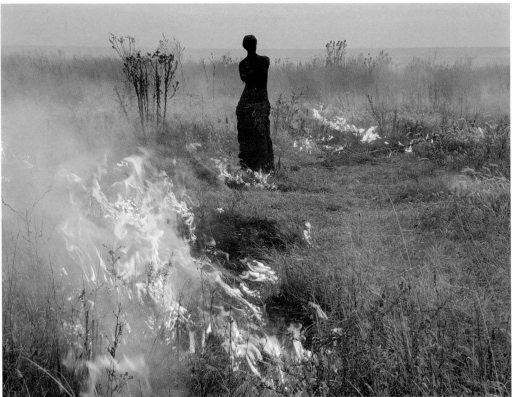

Top: *Venus V*
Bottom: *Venus XI*

Hebru Brantley

Not That Unusual

Mural

Chicago Public Library, Greater Grand Crossing Branch, 1000 East 73rd Street

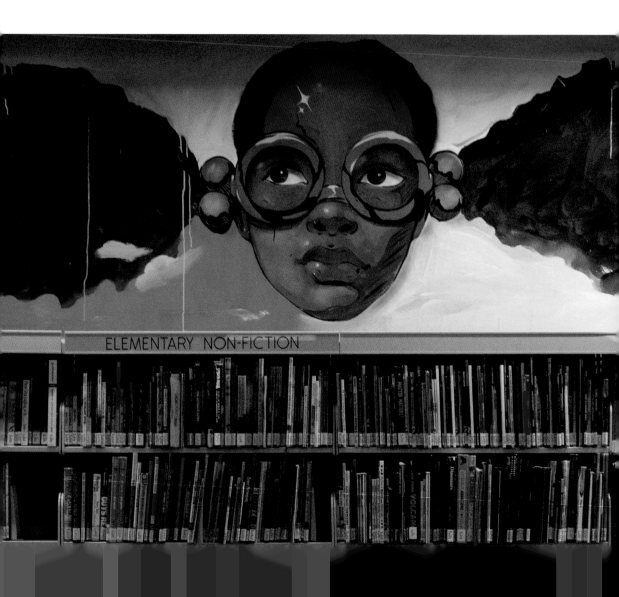

Influenced by the South Side of Chicago's AfriCobra movement, active in the 1960s and 70s, Hebru Brantley creates black characters that draw from American cartoons, murals, and graffiti, along with Japanese anime and manga.

Not That Unusual was commissioned through the City of Chicago Percent for Art program, which is administered by the City of Chicago Department of Cultural Affairs and Special Events (DCASE).

Ellington Robinson

Cerebellum

Painting

Chicago Public Library, Greater Grand Crossing Branch, 1000 East 73rd Street

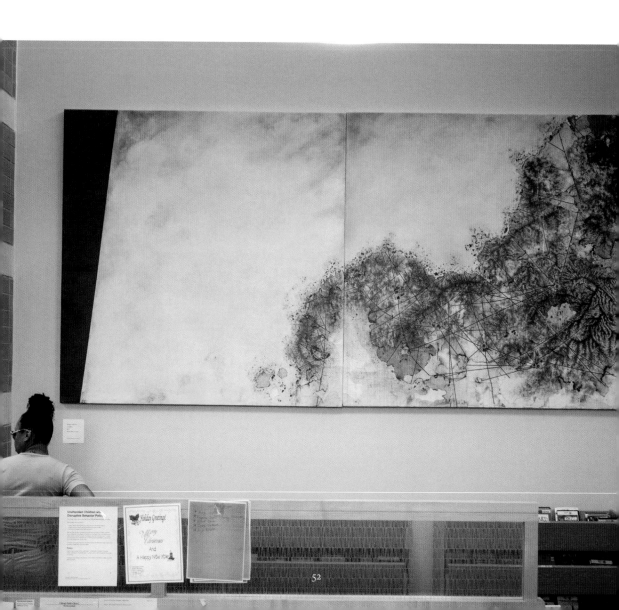

Cerebellum layers materials—interdepartmental office envelopes, inner sleeves of LP record covers, cassette tapes, and graphite—to discuss how ancient civilizations and systems of religion, culture, and education connect with the present.

Cerebellum was commissioned through the City of Chicago Percent for Art program, which is administered by the City of Chicago Department of Cultural Affairs and Special Events (DCASE).

David Morris

Spiral Vortex, 1981
Conserved and renamed *Spiral Rain Form*, 2017
Sculpture
Chicago Police Department, 3rd District—Grand Crossing, 7040 South Cottage Grove Avenue

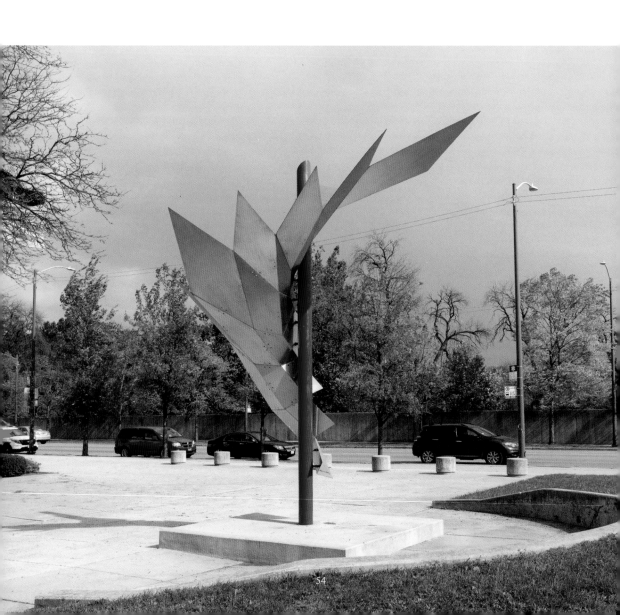

Spiral Vortex was installed at the 3rd District Police Station in 1982. After withstanding over 30 years of Chicago weather, a severe storm caused the main steel sculpture to separate from the supporting shaft. The piece was expertly reconstructed by the skilled local welders of a specialty art fabrication studio and reborn as *Spiral Rain Form* in 2017.

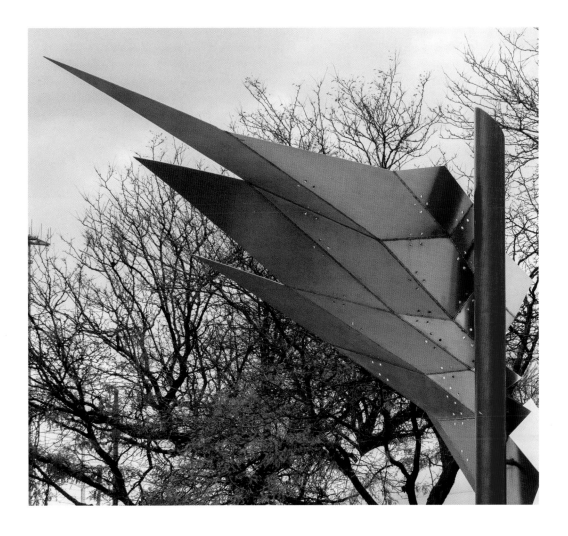

William Estrada

For Freedoms

Community event

Chicago Public Library, Jeffery Manor Branch, 2401 East 100th Street

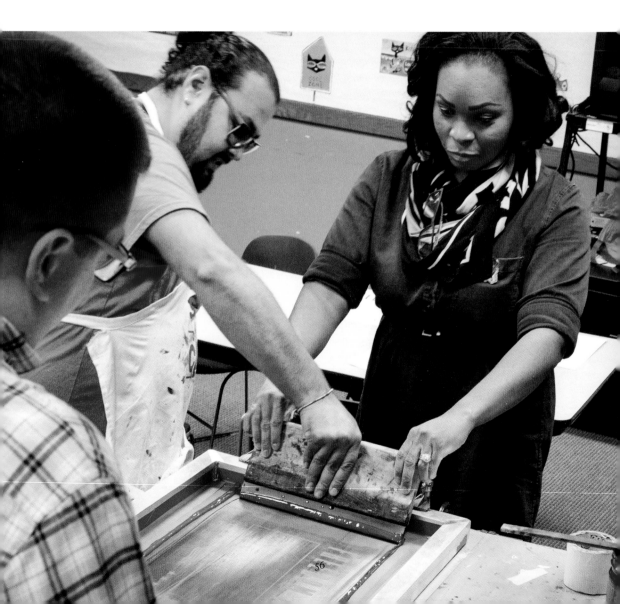

Alderman Gregory Mitchell

As part of *For Freedoms*, a national platform for creative civic engagement, discourse, and direct action, artist William Estrada conducted a screen printing workshop that engaged participants in a discussion about what freedom means to them.

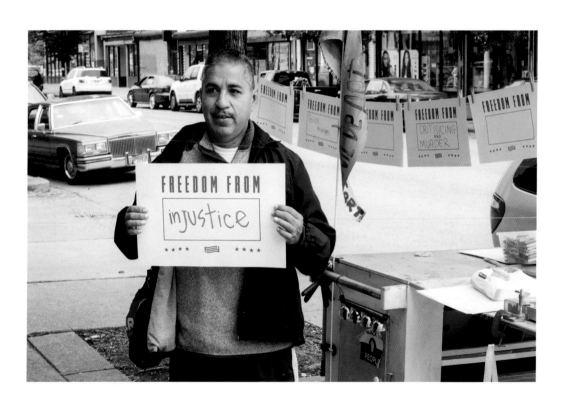

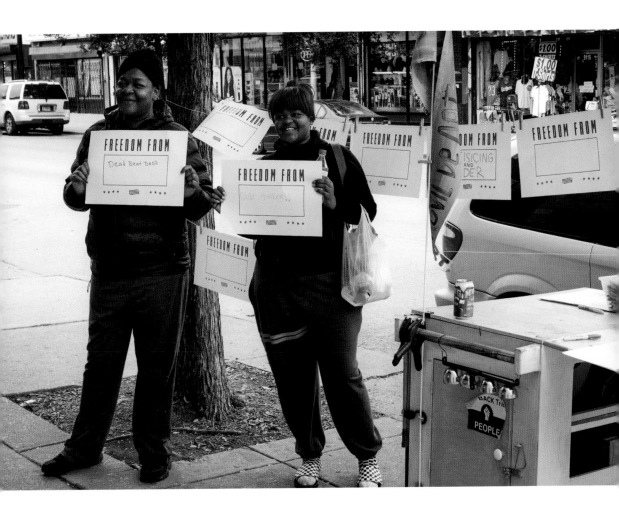

Jim Bachor

Meander

Mosaic

Metra Electric District, Viaduct at 938 East 87th Street

Cut and laid out in the artist's studio, the intricate but simple design of *Meander* shows three tulips—orange, yellow, and red—with their stems undulating along the mosaic's expanse. From a distance, the flowers seem to be blowing in the breeze against an abstracted, rolling landscape.

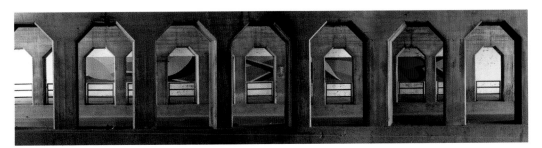

Rahmaan Barnes

Historic Pullman Mural

Mural

Metra Electric District, Pullman Station, 111th Street and Cottage Grove Avenue

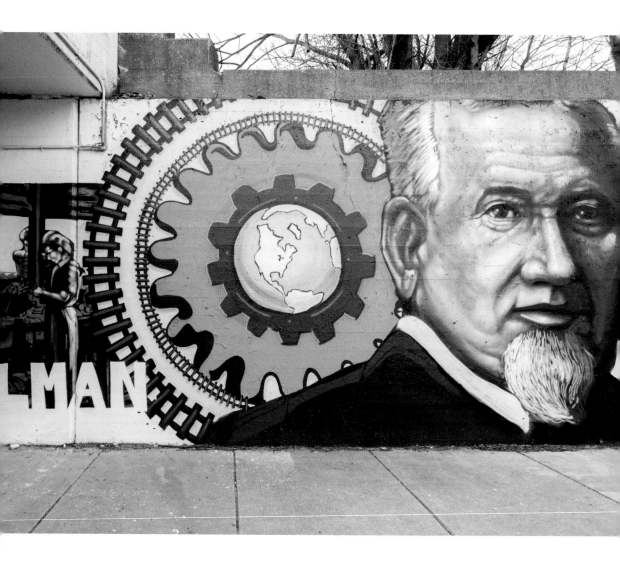

On both sides of the viaduct below the Metra commuter train tracks, the history of the planned community of Pullman is laid out in a series of scenes. Designed by Rahmaan Barnes, the *Historic Pullman Mural* was executed with the help of local high school students.

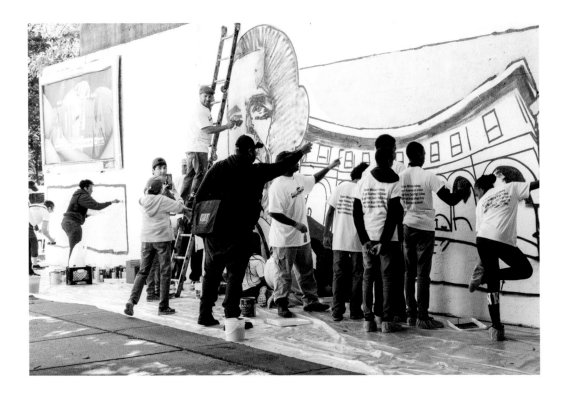

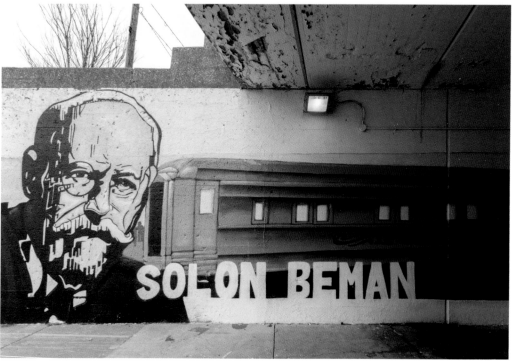

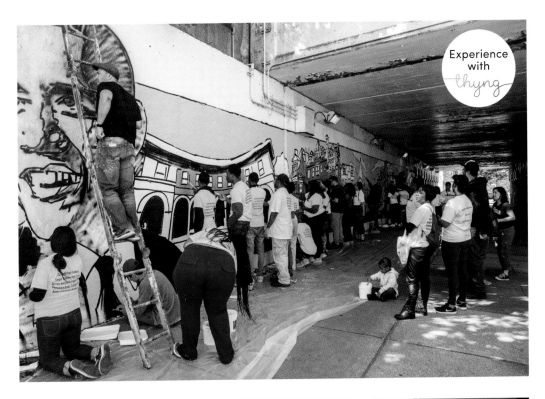

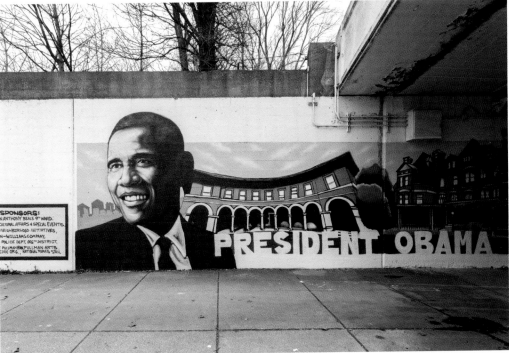

Jeff Zimmermann

with SkyART

Sky Art Mural

Mural

SkyART, 3026 East 91st Street

Jeff Zimmermann began this mural by teaching youth at SkyART how to draw abstract shapes. The shapes they created were enlarged and placed throughout the mural to serve as framing devices for more representational images, including the three faces that gaze directly at the viewer.

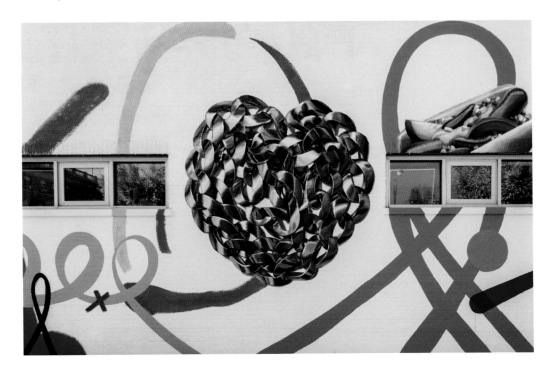

Erica Mott Productions

ELEMENTAL: Spectacles of Earth, Air and Water

Multimedia performance

Chicago Park District, Palmisano Park, 2700 South Halsted Avenue

Experience with
thyng

WARD 11

Alderman Patrick Thompson

Presented in and around the pond at Bridgeport's historic Palmisano Park (formerly Stearns Quarry), *ELEMENTAL* celebrated the history and future of Bridgeport through the lens of three organic elements—earth, air, and water. Over a five-month period, community members, including local high school students from across the 11th Ward, contributed to development and production of the performance.

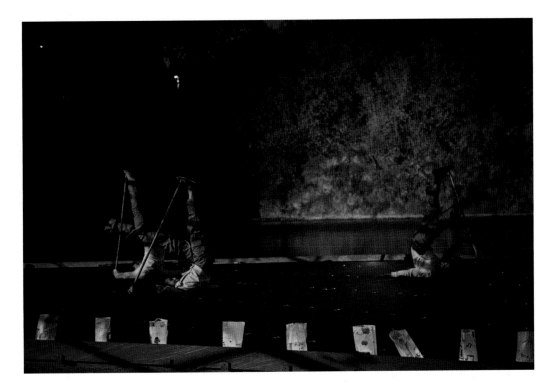

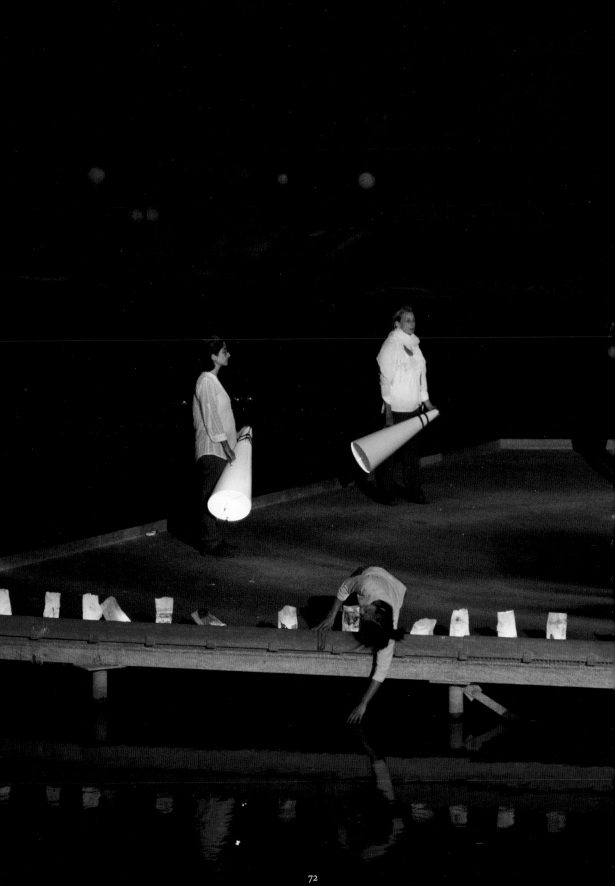

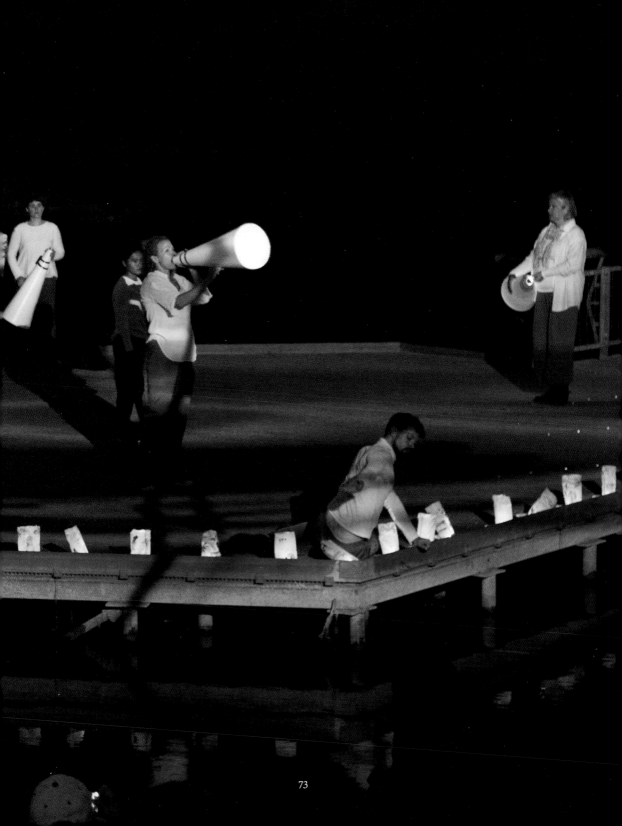

Cyd Smillie
with Arts Alive
Chicago

In Service

Homefront

Murals

Cyd Smillie with Stella Anderson, Aiyana Buchanan, Eileen Fogerty, Elliana Given,
Lindsey Grace, Dan Pogorzelski, Karen Pogorzelski, and Linda Vidmar
Wallace Street viaduct between Pershing Road and 40th Place

These murals honor the extraordinary service of Canaryville veterans to their country and community. Arts Alive Chicago and 11th Ward Alderman Patrick Thompson's office organized two community project days—one for neighborhood students and one for local residents—with over 120 volunteers helping to realize *In Service* and *Homefront*. Together, the murals emphasize the profound power of connection between service members, their families, and community.

Anthony Heinz May

Natura non confundenda est

Sculpture

Chicago Park District, McKinley Park, 2210 West Pershing Road

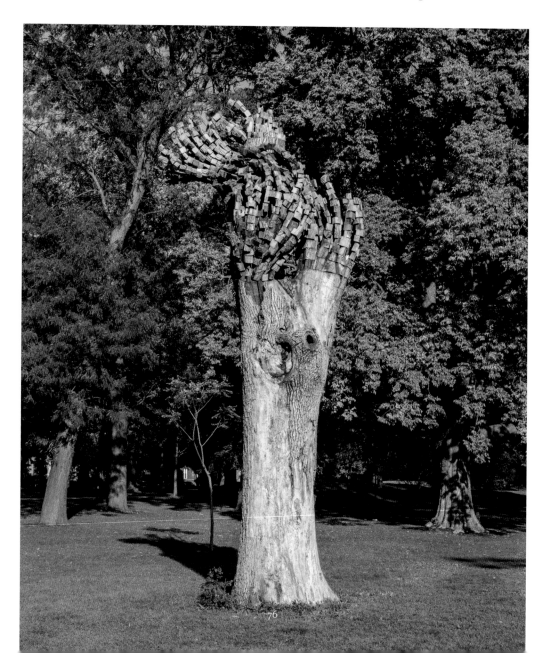

Alderman George A. Cardenas

Natura non confundenda est roughly translates from Latin as "Do not confuse mother nature." The sculpture began with a naturally destructive process, when an ash tree succumbed to the emerald ash borer beetle. May's work contributes to the Chicago Tree Project (CTP) collaboration between the Chicago Park District and Chicago Sculpture International. Each year, CTP selects sick and dying trees from throughout the city to be transformed into public art.

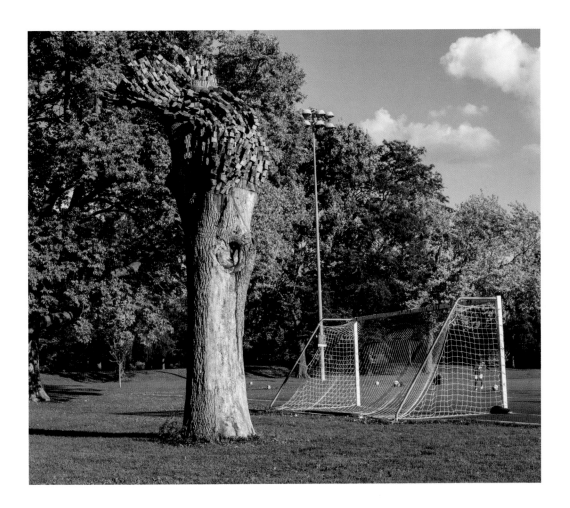

Alberto Aguilar

Double Vision/Doble Visión

Temporary installation (no longer on view)

5850 West 63rd Street

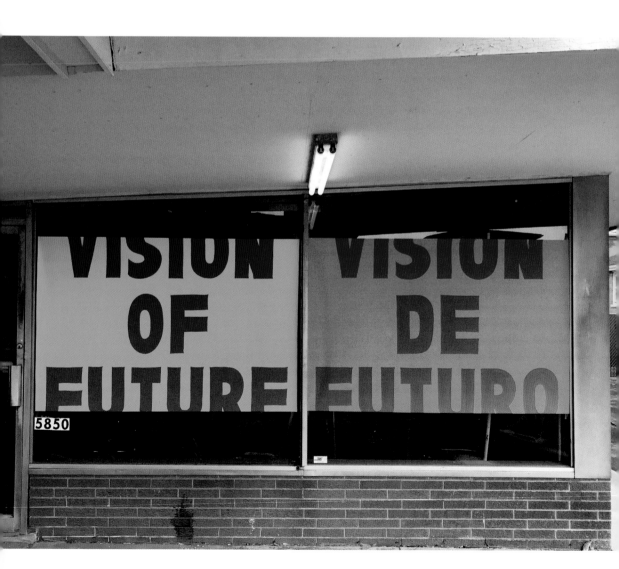

At 63rd and Pulaski stands a 14-foot fiberglass statue of a Native American, originally erected in 1966 by the store below, Capitol Cigar Stores Co., with a banner on his chest advertising White Owl Cigars. The statue now wears eyeglasses, and the replaced banner reads "Eye Can See Now."

West of this corner, at 63rd and Central, is a sign painting business which Aguilar uses for the production of his artwork, and which supplies hand-painted signs to businesses across the city. Addressing the westward migration of Mexican Americans and the future of the 13th Ward of Chicago, Aguilar commissioned two signs, which read "Vision of Future" in English and Spanish. They occupy the storefront windows of a former Dog N Suds—later a dry cleaner—further west of the sign shop and the statue.

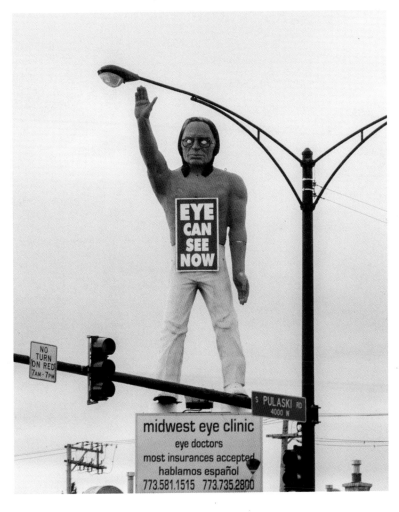

Kirsten Leenaars

Producers of Change: Y Hoy, Como Siempre, Sois Imprescindibles
Temporary installations (no longer on view)
Chicago Public Library, Archer Heights Branch Library, 5055 South Archer Avenue
Greater Food Depository, 400 West Ann Lurie Place
Park Place Apartments, 3630 West 51st Street

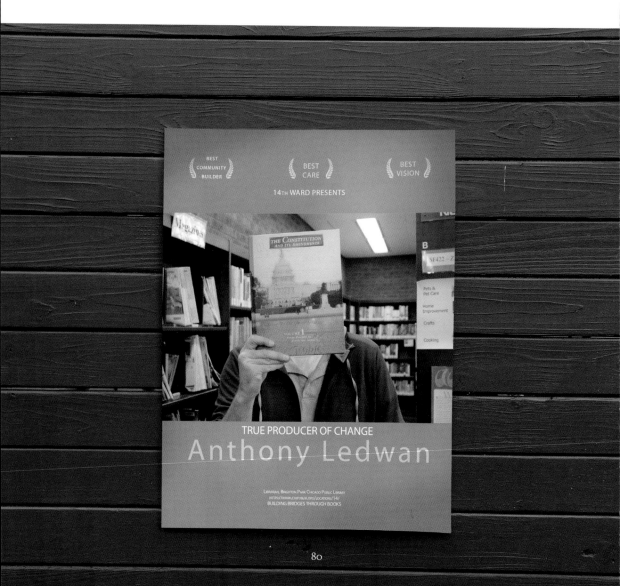

Kirsten Leenaars, with fellow artist Jim Duignan, compiled a list of 14th Ward residents who have contributed to positive change in their neighborhood. Leenaars photographed these change-makers to create their portraits at the locations in the neighborhood where the individuals "create change." The posters were then hung where the photograph was taken, so that the poster, portrait and site, all become the "stars" of the neighborhood.

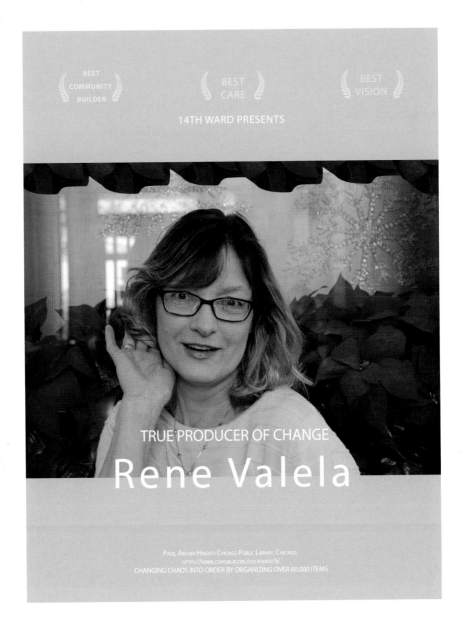

BEST COMMUNITY BUILDER

BEST CARE

BEST VISION

14TH WARD PRESENTS

TRUE PRODUCER OF CHANGE

Craig Chico

President & CEO Back of the Yards Neighborhood Council, Chicago,
https://parkplaceapartmentliving.com/
SERVING THE COMMUNITY HOLISTICALLY

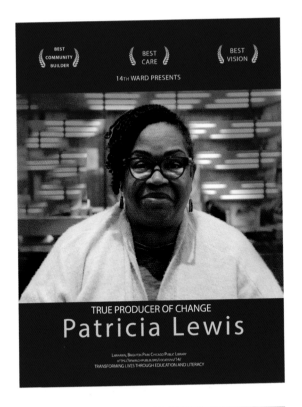

Cyd Smillie
with Arts Alive
Chicago

Messages
King of Peace
Murals
Viaduct at 5804–5856 South Damen Avenue

Cyd Smillie worked with Henderson Elementary students and faculty on the theme of peace for two corresponding murals on the walls of the Damen underpass—*Messages* on the east side, and *King of Peace* on the west side. *King of Peace* was designed by Henderson Elementary art teacher Darrell Pulliam, while Cyd Smillie designed *Messages* with the Henderson students.

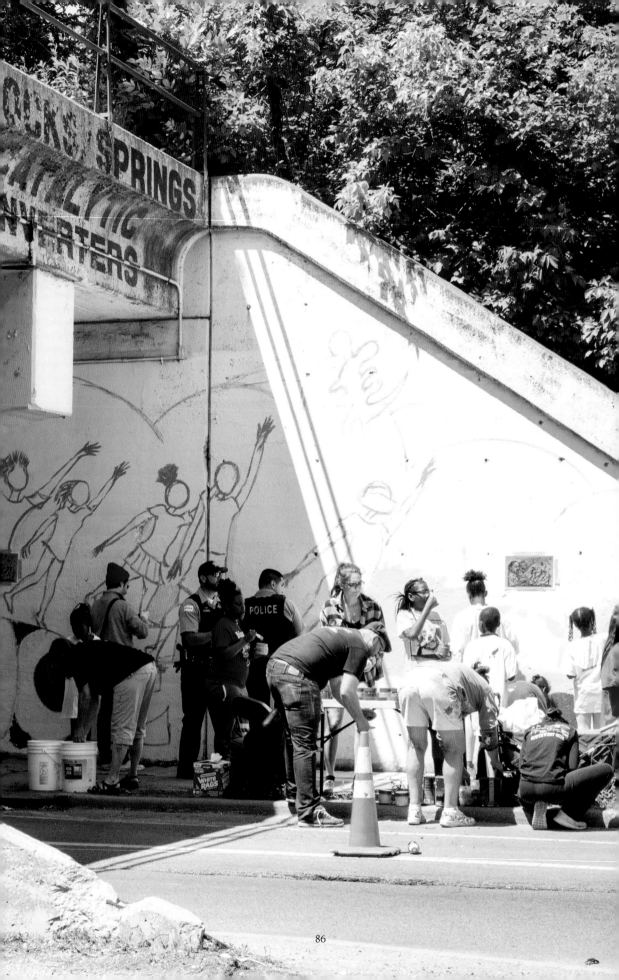

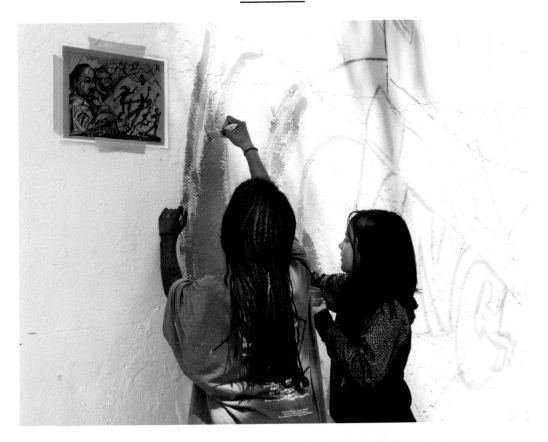

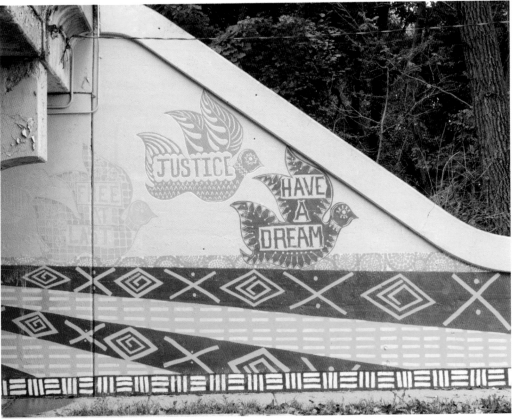

Max Sansing

63rd and Infinity
Mural
833 West 63rd Street

Latent Design

Boombox Englewood
Installation
833 West 63rd Street

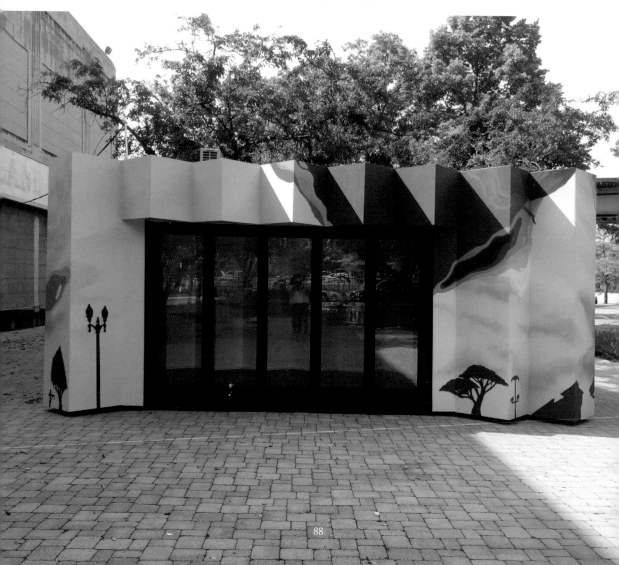

In creating the mural with spray paint for *Boombox Englewood*, Matt Sansing has depicted a silhouette of a different Chicago skyline, featuring elements within the surrounding blocks in Englewood. This location is one of four *Boombox* installations across the city managed by Latent Design.

This project was realized in partnership with the People Plazas program of the Chicago Department of Transportation's Make Way for People initiative, and the Department of Planning and Development's Retail Thrive Zone program.

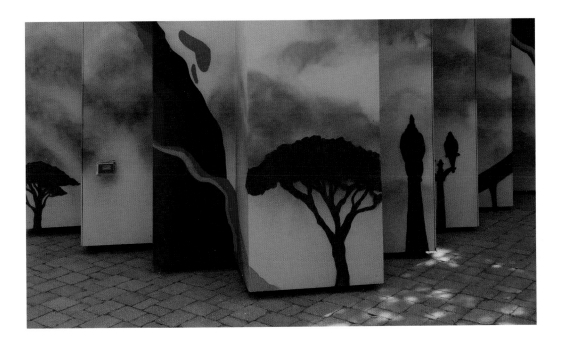

Bryant Jones
with Joi-Anna Huff
and JoVonna Jackson

The Community Information Project
Sculpture
17th Ward, various locations

WARD 17

Alderman David Moore

Designed to fill a need identified by Alderman David Moore, *The Community Information Project* is an installation of boxes that disseminate print information to community members who have limited access to technology. Based on sculptural design work by Joi-Anna Huff, artist Bryant Jones and his Art Warriors modified, built, and painted the installed pieces, and JoVonna Jackson integrated the mosaics.

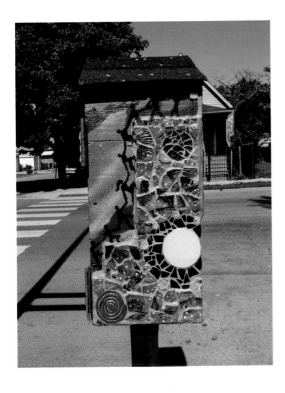
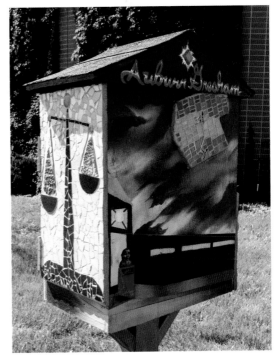

Green Star Movement

We Are One

Mosaic

Viaduct at 79th Street and Kedzie Avenue

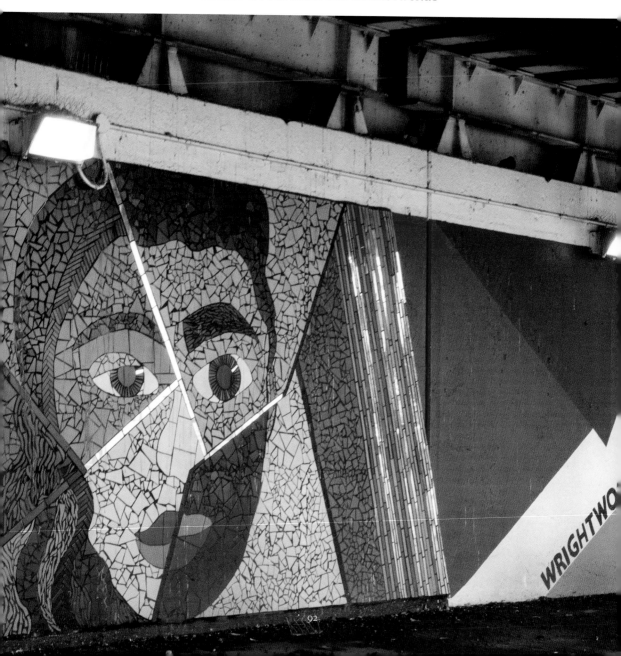

Alderman Derrick Curtis

Green Star Movement responded to the 18th Ward's request for a mural design that would connect the neighborhoods that make up the ward: Auburn Gresham, Ashburn, Chicago Lawn, Scottsdale, and Wrightwood. The mosaic seeks to showcase the diversity of the area, make the prominent viaduct more pedestrian friendly, and highlight that many ward residents are civil servants—including police and firefighters.

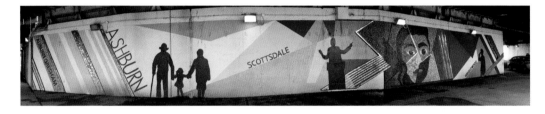

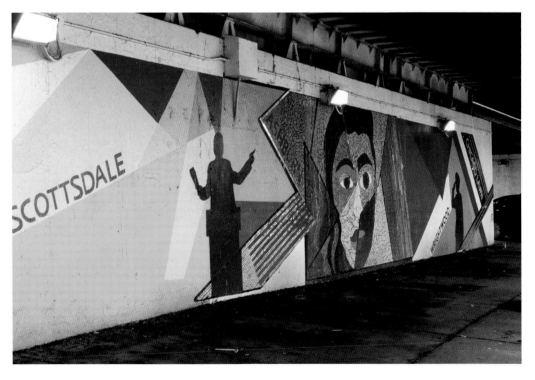

Davis McCarty

Quantum Me

Sculpture

Metra Rock Island District, Beverly Hills station, 99th Street and Walden Parkway

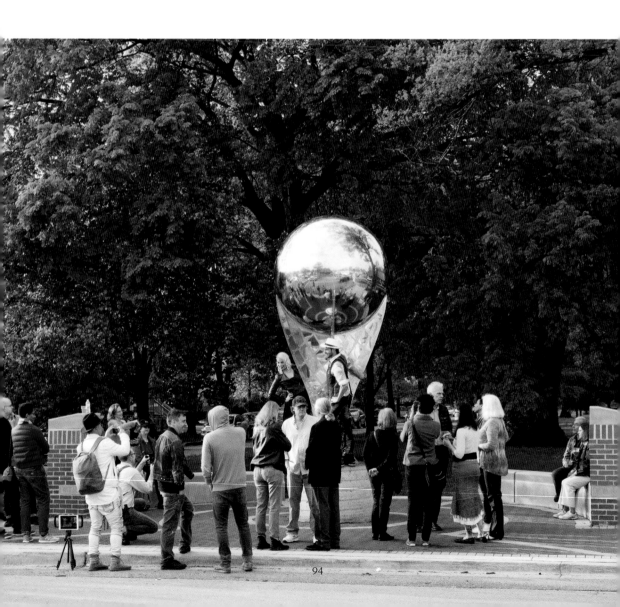

Quantum Me literally and figuratively reflects its surroundings. Multicolored panes of purple, green, and amber dichroic Plexiglas support a stainless-steel sphere that creates a kaleidoscopic experience unique to each passerby. A second piece by McCarty, *Quantum Dee*, located in the Rogers Park neighborhood in the 50th Ward, is an inversion of this sculpture (shown on page 222).

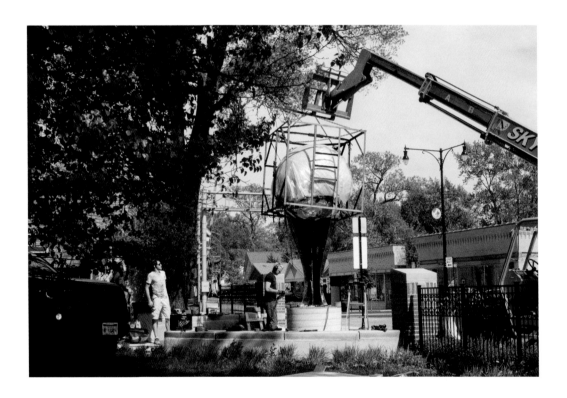

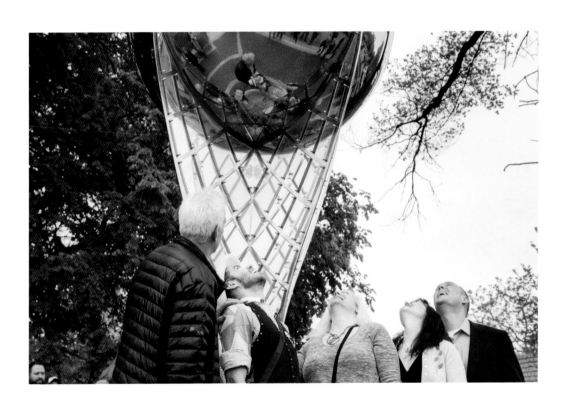

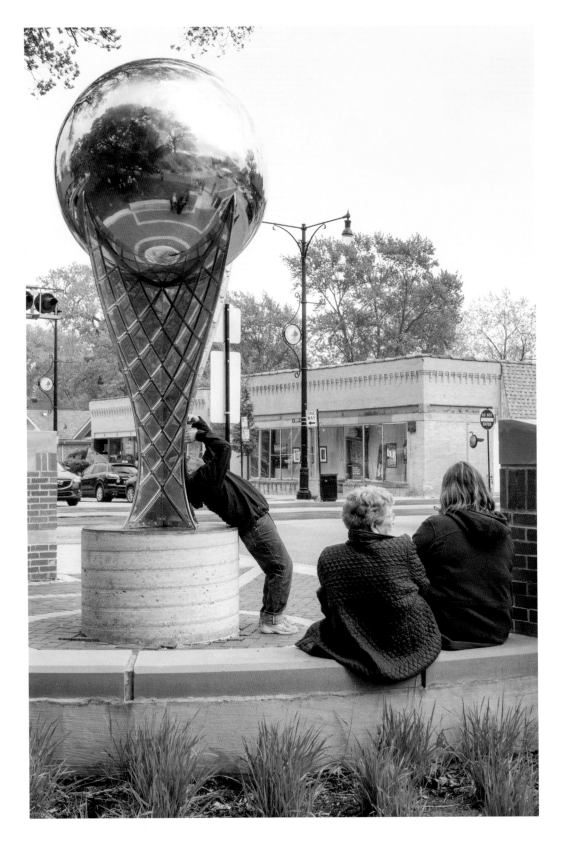

Green Star Movement

Woodlawn Gateway at 65th

Mosaic

Viaduct at 65th Street and Dorchester Avenue

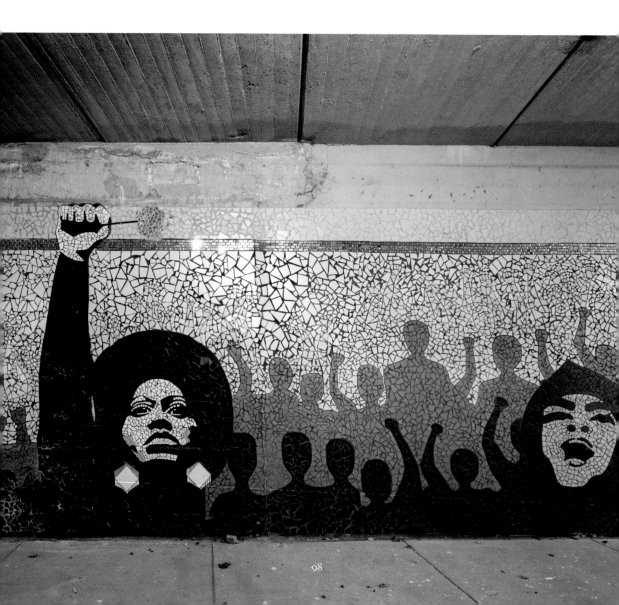

Green Star Movement, with the help of approximately 500 volunteers, created this mosaic to celebrate the Woodlawn neighborhood and its culture. Elaborate portraits of notable Chicagoans, including Barack and Michelle Obama, and singer Minnie Riperton, are shaped from tile. Photographs embedded in the material memorialize other former residents—including Emmett Till and Muhammad Ali.

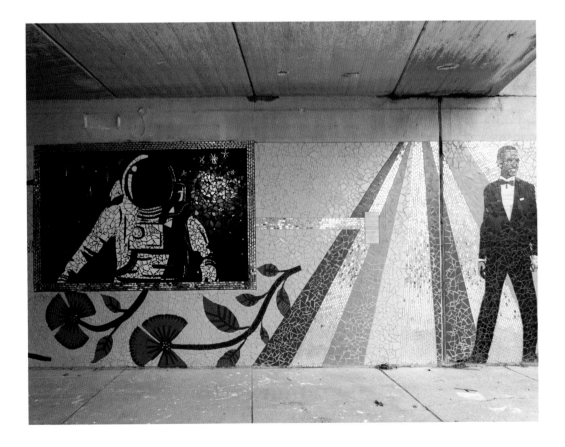

Port Ministries

with **Gloria "Gloe" Talamantes**

We Grow Here Too
Mural
Mujeres Mutantes (Jacqui Almaguer, Laura Gomez, Teresa Magaña,
Adriana Pena) and Port Ministries' People's School
Viaduct at Garfield Boulevard and Wallace Street

When scouting the location for her mural with Port Ministries, artist Gloria "Gloe" Talamantes thought about the homeowners who refused buyouts for the Norfolk Southern railroad freight yard expansion in Englewood. Believing in the healing properties of flowers, she has incorporated flowers in her mural to surround people as they walk and ride by the mural.

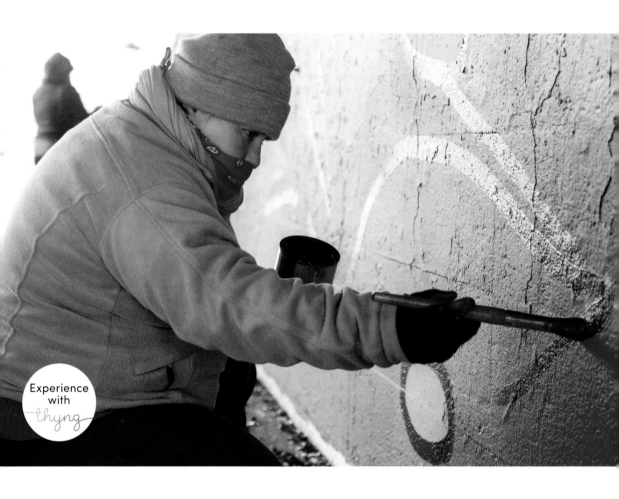

Experience with thyng

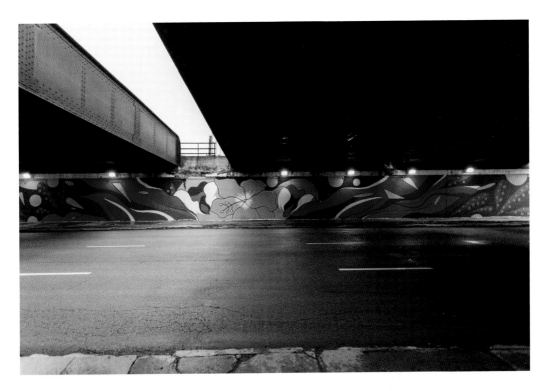

Rahmaan Barnes

The Great Wall of Chicago

Mural

Metra Rock Island District, Gresham station, 87th Street and South Vincennes Avenue

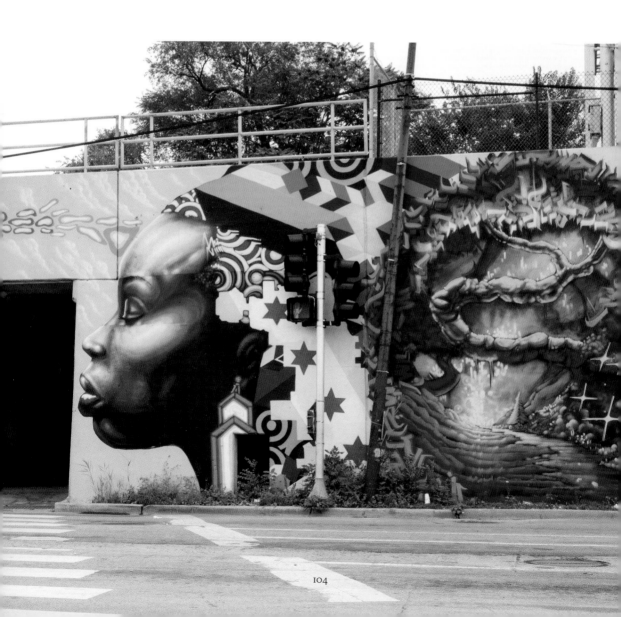

In *The Great Wall of Chicago*, Barnes situates portraits of Auburn Gresham residents in an environment that is both local and cosmic. North of the viaduct, several figures surround a globe, with the night sky and a constellation integrated into their figures. Barnes notes that the mural promotes mental health and, through these profiles, he suggests we each have an interior world that can relate to an expansive universe. The figures south of the viaduct are grounded in Chicago. The profile of a blue figure contains a verdant path with a lakefront scene continuing into an abstracted landscape. A young woman with a megaphone symbolizes speech and political action. A young man in a white hoodie, painted by fellow artist Max Sansing, gazes upward in thought. Throughout, Barnes thematizes improving oneself and one's community.

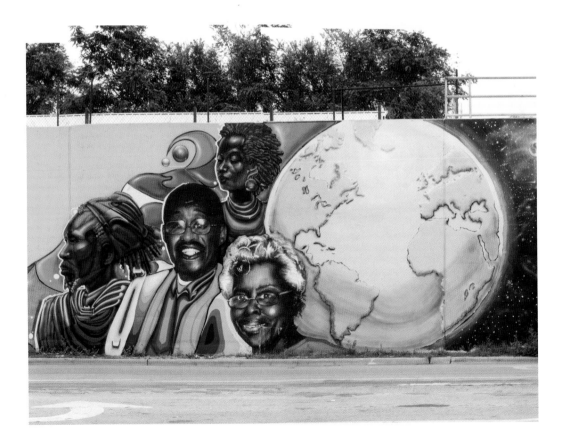

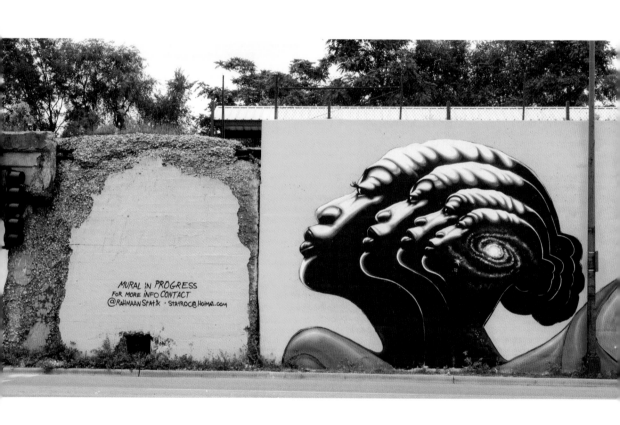

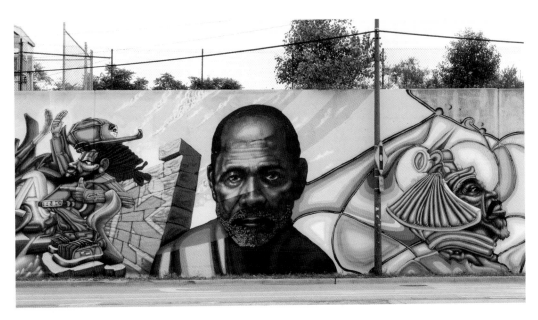

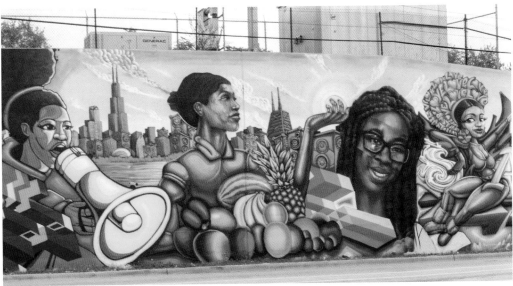

Yollocalli Arts Reach

Murals

Far Beyond

Corkery Elementary School, 2510 South Kildare Avenue

Mother Nature

Cyrus H. McCormick Elementary School, 2712 South Sawyer Avenue

Together We Fly Higher

Lázaro Cardenas Elementary School, 2406 South Central Park Avenue

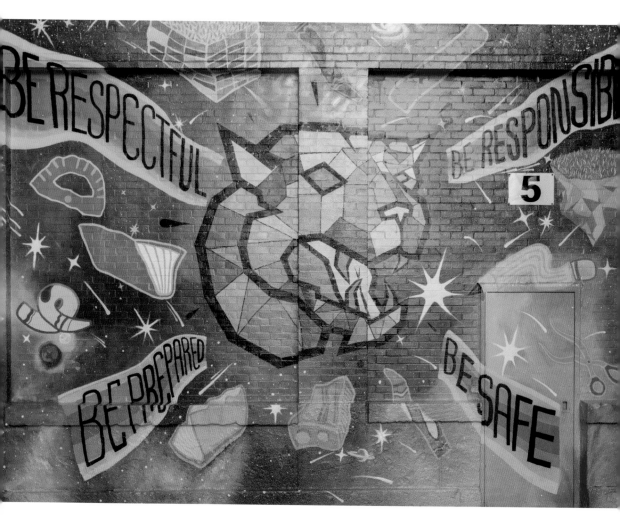

In the summer of 2017, youth participants from Yollocalli Arts Reach, with the guidance of professional art mentors, created murals for three Chicago Public Schools. Yollocalli Arts Reach is an initiative of the National Museum of Mexican Art. Since 1997 it has been a space for youth to explore their creative interests and to thrive as active members of Chicago's creative community.

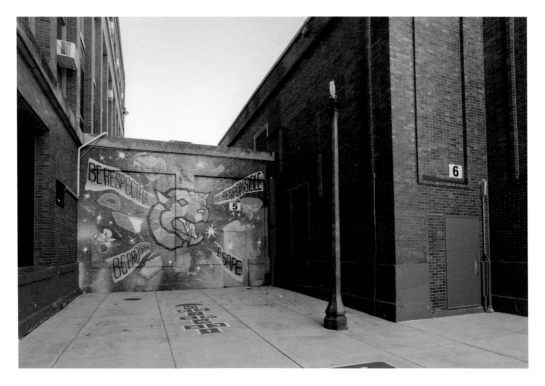

Far Beyond

Above and at right, top: *Mother Nature*

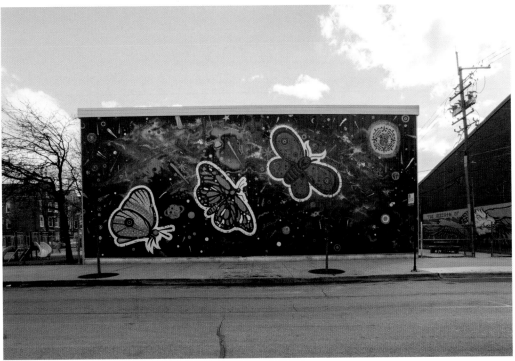

Together We Fly Higher

Margaret Wharton

Rehearsal

Conserved 2017

Sculpture

Chicago Public Library, West Lawn Branch, 4020 West 63rd Street

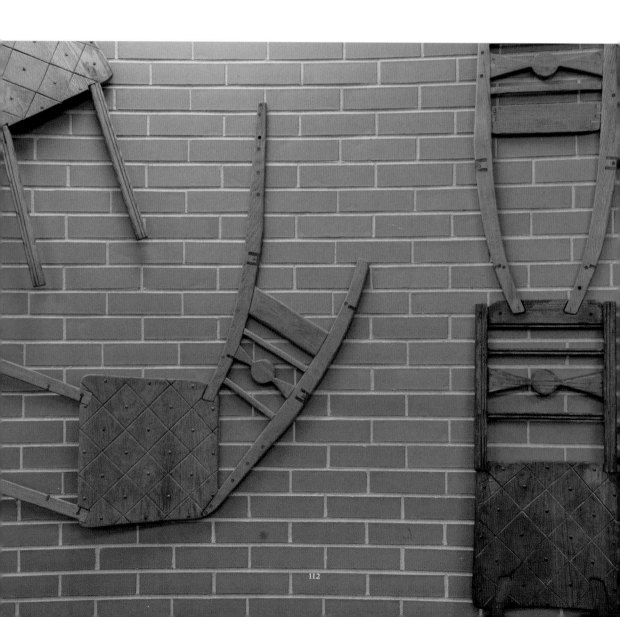

Rehearsal is a wall sculpture comprised of four red oak chairs, which was originally created in 1986. Its primary material, wood, naturally expands and contracts. Over the years, this natural movement led to several joints coming unglued. To repair the artwork, conservators rejoined and remounted several of its elements.

Rehearsal was commissioned through the City of Chicago Percent for Art program, which is administered by the City of Chicago Department of Cultural Affairs and Special Events (DCASE).

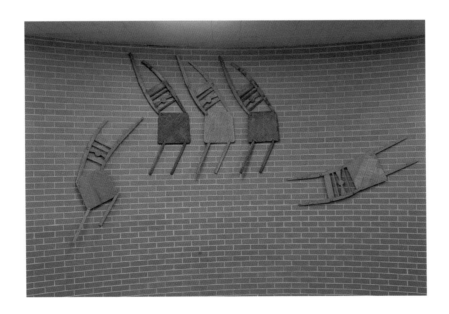

School of the Art Institute of Chicago

and Pedro Reyes

Oaks of North Lawndale
Installation
North Lawndale, various locations

Artist Pedro Reyes was asked to restage his work *Palas por Pistolas* (*Guns into Shovels*). SAIC students, alumni, 24th Ward residents, and students from Greater West Town Partnerships, worked with the artist to melt down confiscated firearms and turn them into shovels. This project is a symbolic beginning of the eventual planting of 7,000 trees in North Lawndale, which will transform the neighborhood into a verdant, peaceful, tree-lined place.

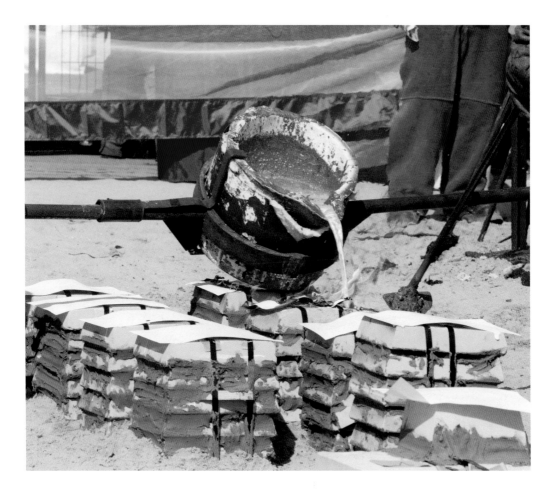

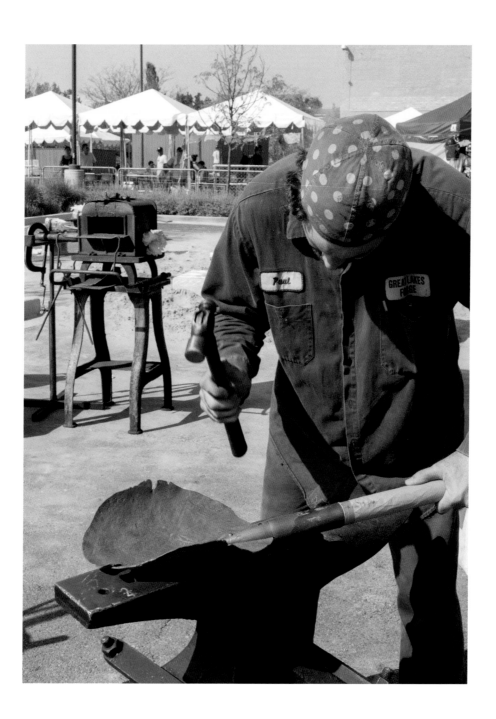

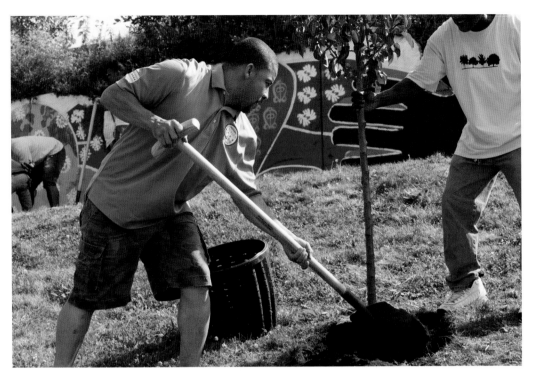

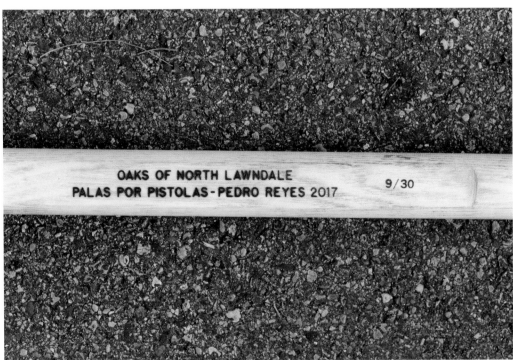

OAKS OF NORTH LAWNDALE
PALAS POR PISTOLAS - PEDRO REYES 2017 9/30

El Paseo Community Garden

El Abrazo (The Embrace)

Mural

Eric J. Garcia, Diana Solís, Katia Péres-Fuentes

El Paseo Community Garden, 944 West 21st Street

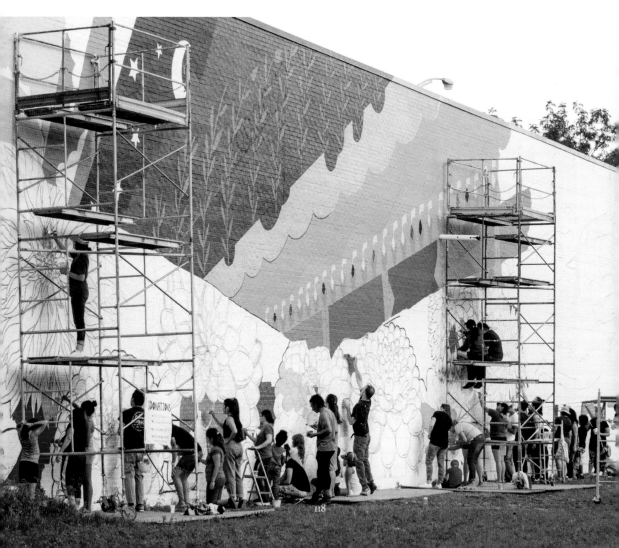

El Abrazo (*The Embrace*) was initiated by the directors of El Paseo Community Garden, Paula and Antonio Acevedo who assembled the team of local Pilsen artists—Eric J. Garcia, Katia Pérez Fuentes and Diana Solís. Five teenage apprentices were also hired to join the multi-generational mural team for a span of 3 months. The community-driven mural explores histories and themes that are important to the surrounding community - migration, agriculture, and cultural identities. The dedication—with Maizal Macuil-Xochitl dancers —was hosted in conjunction with the garden's annual Harvest Festival and during the 15th annual Pilsen Open Studios art walk.

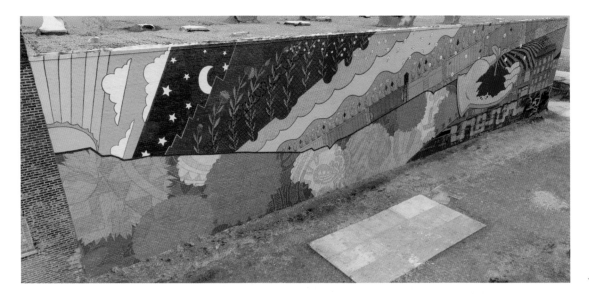

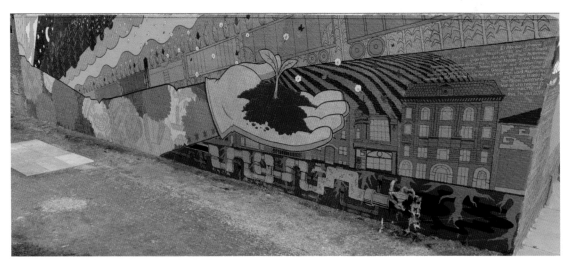

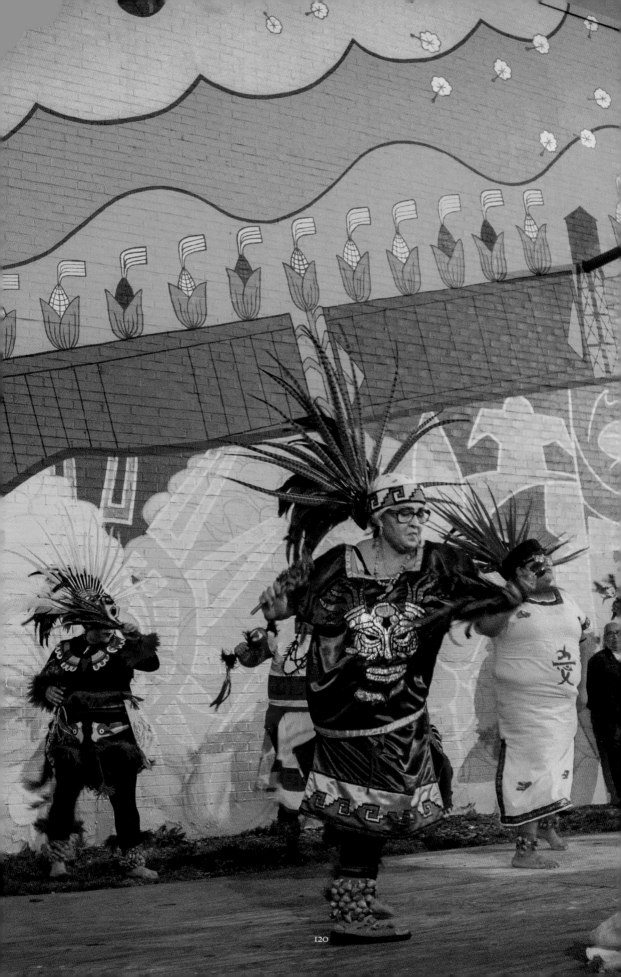

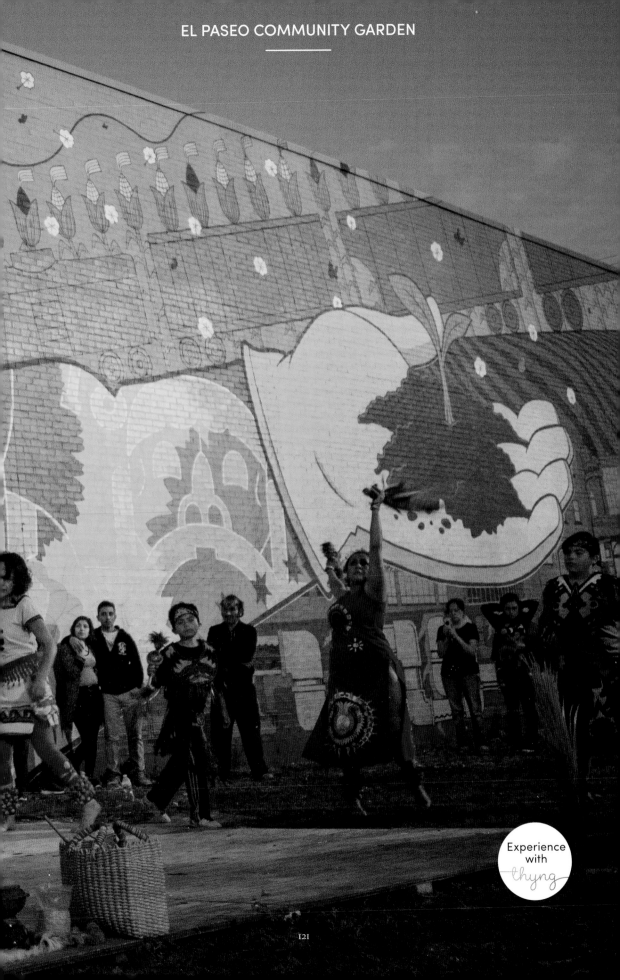

Experience
with
thyng

Sam Kirk

Las Puertas de Paseo Boricua
Mixed media
Sandra Antongiorgi, Sam Kirk, Julio Cesar Montano-Montenegro, Lebster Pabon,
Josue Pellot, Jasmine Petersen, Jenny Q., Marcos Rios, Reynaldo Rodriguez,
Cristian Roldan, Missy Rosa, Edra Soto, and John Vergara
Division Street between Western Avenue and California Avenue

Las Puertas de Paseo Boricua, organized by Sam Kirk with Cristian Roldan, is a celebration of contemporary Latino culture in Chicago. Partnering with the Illinois Puerto Rican Cultural Center, Kirk sought out street-level doorways on Division Street as new sites for public artwork, to increase the visibility of Latino culture in Humboldt Park. Kirk selected 13 artists to create new works that explore indigenous tribes, ancestry, cultural characters, music, scenic references, cross-cultural identities, and pride.

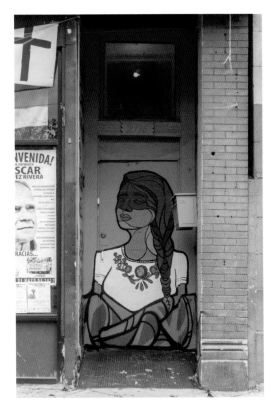 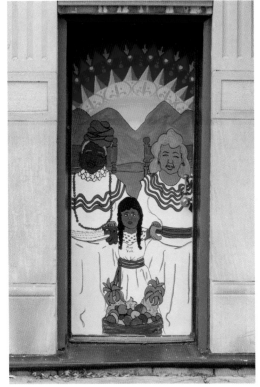

At left: **Sandra Antongiorgi**
Above, left: **Sam Kirk**
Above, right: **Jenny Q.**

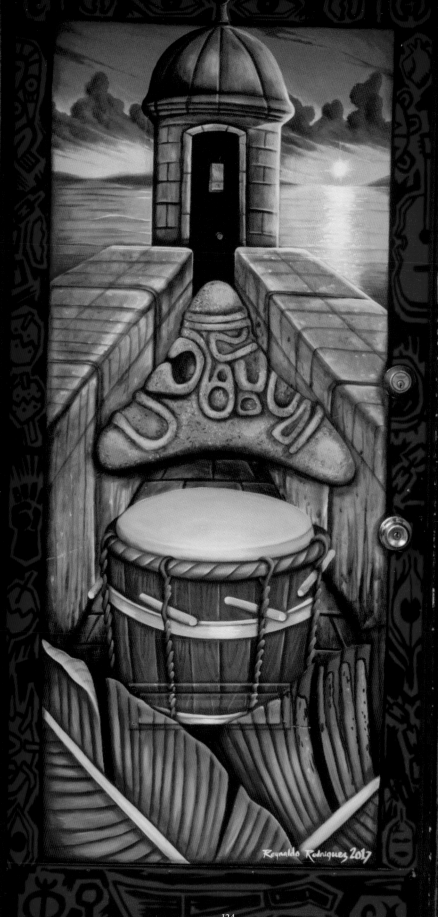

Reynaldo Rodriguez 2017

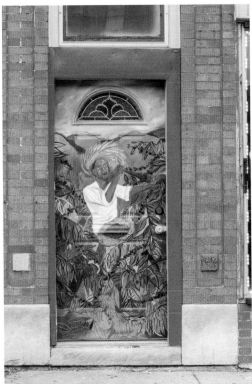

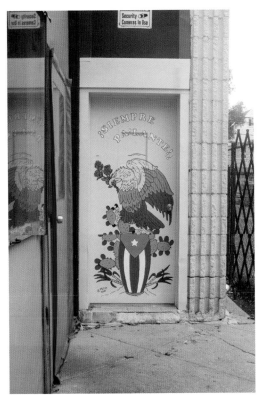

Above, top: **Edra Soto**
Above, bottom: **Cristian Roldan**
At left: **Reynaldo Rodriguez**

Above, top: **Lebster Pabon**
Above, bottom: **Missy Rosa**

Amanda Williams

Ease on Down the Road
Installation
Western Avenue and Adams Street

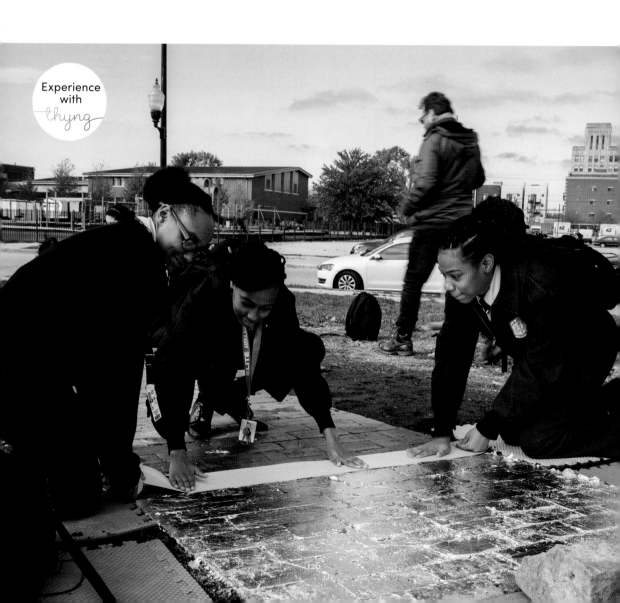

Experience with *thyng*

Alderman Walter Burnett, Jr.

Following an informal walkway that 27th Ward residents created through a vacant lot, gold-leafed brick pavers now create a golden path. The project serves as a hopeful reminder to students and residents. Whether viewers know the yellow brick road from *The Wiz!* or *The Wizard of Oz*, it acts as a symbol of freedom and possibility. Students from the nearby Phoenix Military Academy selective enrollment high school worked with artist Amanda Williams to realize the project.

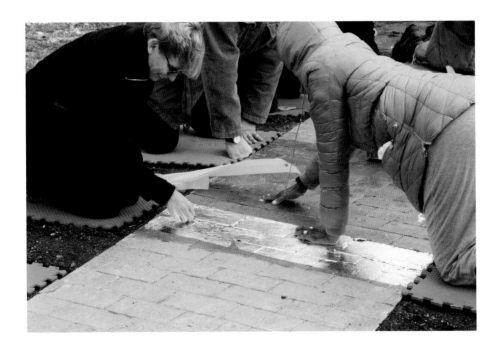

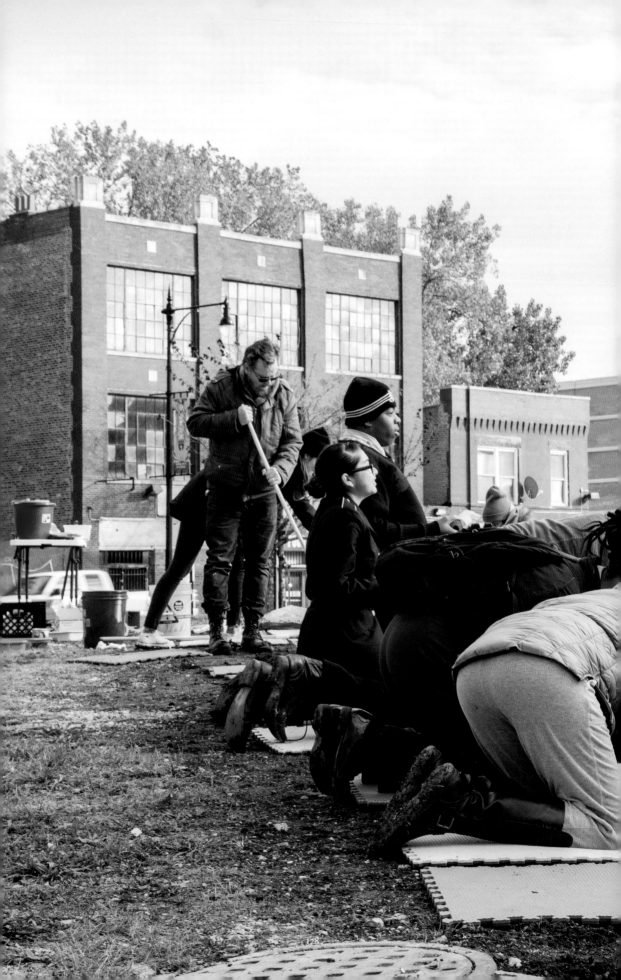

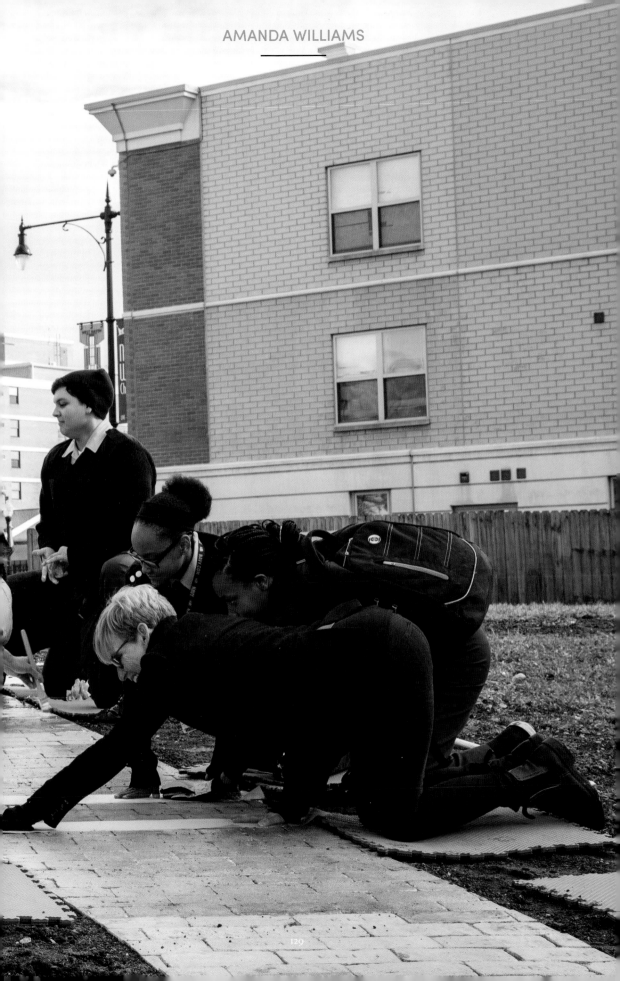

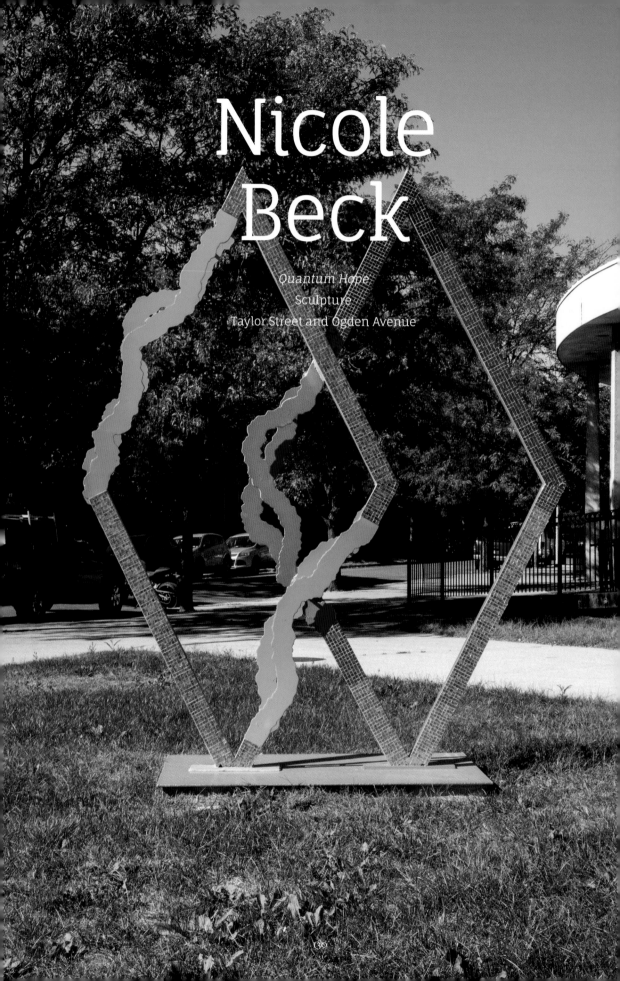

Nicole
Beck

Quantum Hope

Sculpture

Taylor Street and Ogden Avenue

Quantum Hope channels the basic principle of kinetic energy into a site-specific work. Installed within sight of the Cook County Juvenile Temporary Detention Center, the Jesse Brown VA Medical Center, and Stroger Hospital, the sculpture expresses sentiments of recovery, aspiration, and positive energy between these facilities.

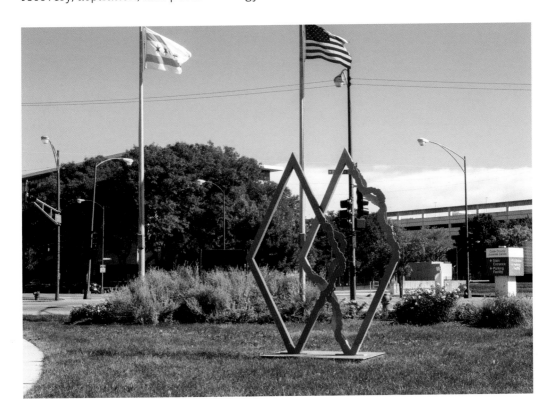

Jesús Acuña

Tribute to Ray Charles Easley

Sculpture

Chicago Transit Authority, bus terminal at Chicago Avenue and Austin Boulevard

Sited at the CTA terminal along the western border of Chicago, these larger-than-life sculptures honor the community and civil rights advocacy of Ray Charles Easley (1957–2013), a lifelong Chicago resident and leader of the Westside Branch NAACP.

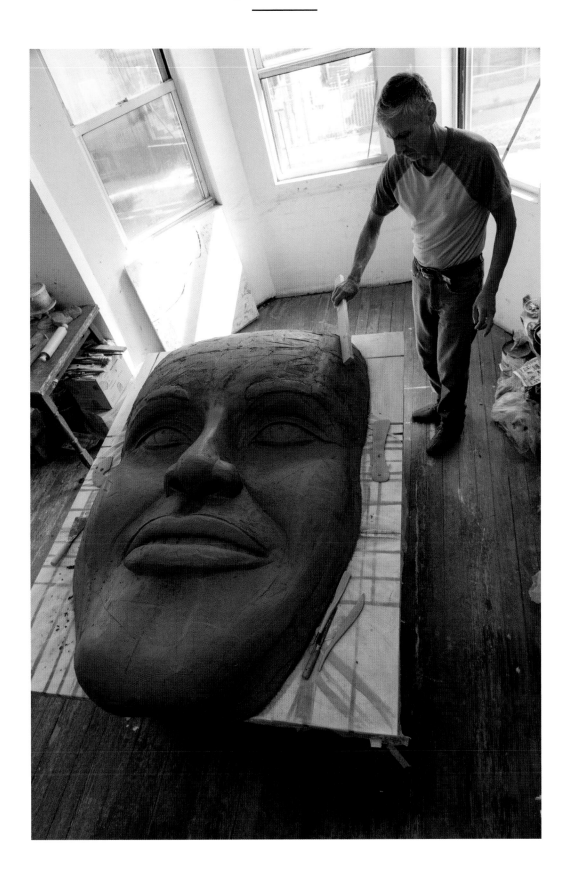

Northwest Arts Connection

Northwest Arts Connection (NAC) curated and supervised
four murals in the 30th Ward, bordering Kilbourn Park:

Ken R. Klopack
Neighborhood Renewed
Addison Street at Kilbourn Avenue

AnySquared Projects
Tracy Kostenbader, Rosa Pineda, and Holiday Gerry
Becoming
Roscoe Avenue at Kostner Avenue

Erika Doyle
Jardin Kilbourn
Roscoe Avenue at Kostner Avenue

Keith Pollok
Neighborhood on the Rails
Belmont Avenue at Kildare Avenue

Part of the 30th Ward is a former industrial corridor that is becoming residential. The artists who created these murals responded to the question, "What does urban renewal or urban evolution mean to this area?"

Below: *Neighborhood Renewed*

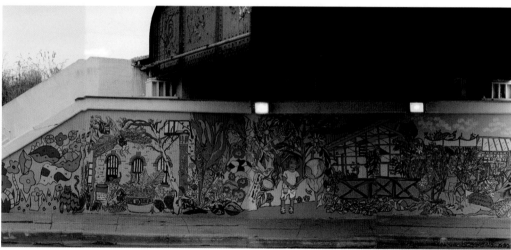

Above, top: *Becoming*
Above, bottom: *Jardin Kilbourn*

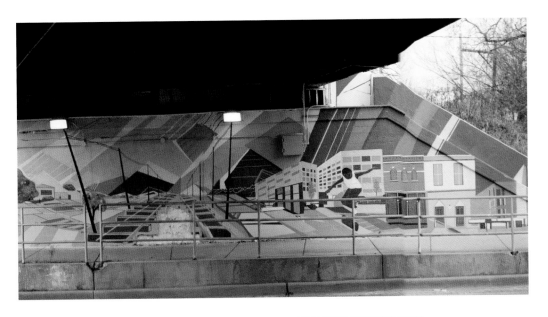

Above, top: *Neighborhood on the Rails*

Jeff Zimmermann

The People of the Garden

Mural

4211 West Diversey Avenue

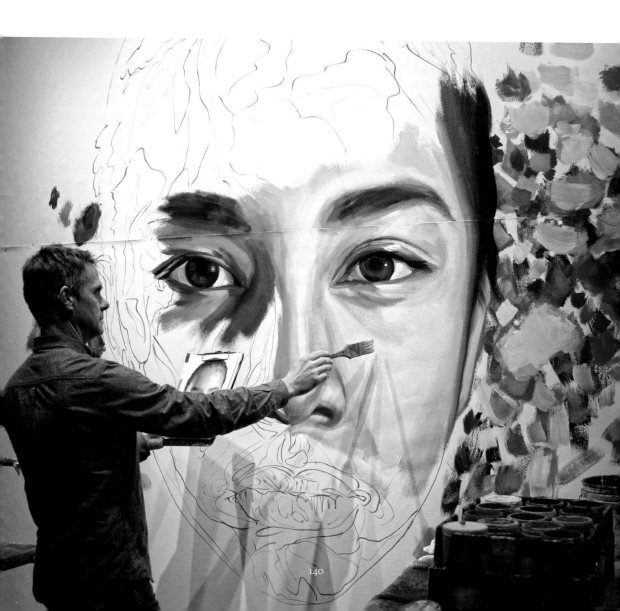

Jeff Zimmermann uses pop culture imagery, combined with thoughtful portraits of everyday residents, to celebrate and comment on the communities he memorializes in his murals. In this mural, Zimmermann aims to portray the dignity of the residents of the 31st Ward, including the likenesses of a mix of old and young community members. Their portraits may at first appear very serious, but after spending time with them the viewer will begin to perceive a subtle smile with a sense of welcoming. Bright colors and dynamic designs represent the hustle and activity of the neighborhood, while geometric shapes reference the idea of building community.

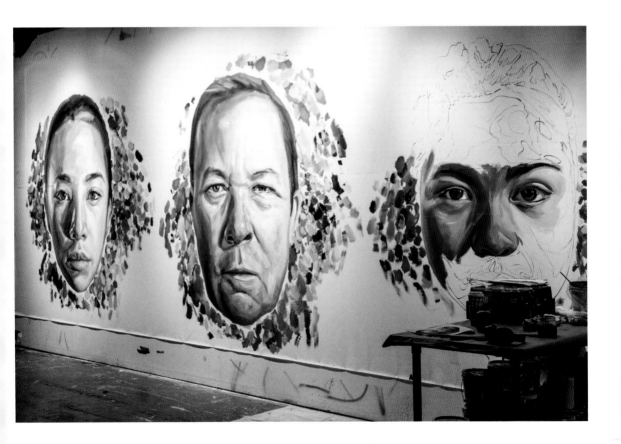

Tony Passero

CoyWolf

Mural

Viaduct, Damen Avenue at The 606

In *CoyWolf*, two large animals patterned with vibrant shapes stare at the viewer with boldly colored eyes. The coyote/wolf hybrids depicted in the mural now stand as icons of The 606, the nearby innovative public recreation space.

Territory

Bridging the Distance
Seasonal installation
Sites variable

Helen Slade, Executive Director of Territory NFP, led After School Matters teens to create *Bridging the Distance*. After three pop-up community events, the team focused their design on the concept of play. The modular design is made of simple materials that are easy to assemble, move, and reconfigure at different sites throughout the neighborhood.

Bridging the Distance is a "People Spot"
created through the Chicago Department of
Transportation Make Way for People initiative.

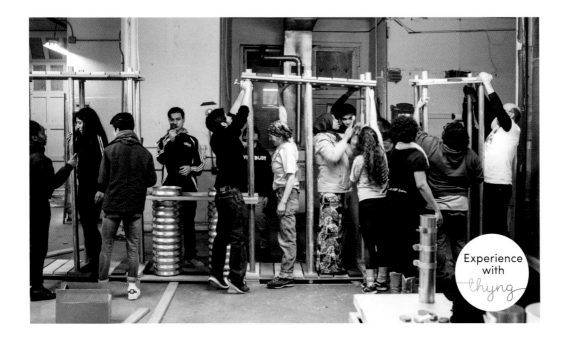

Experience
with
thyng

Jabberwocky Marionettes

Savanna Arts & Music Parade

Performance

Chicago Park District, West Pullman Park Cultural Center, 401 West 123rd Street

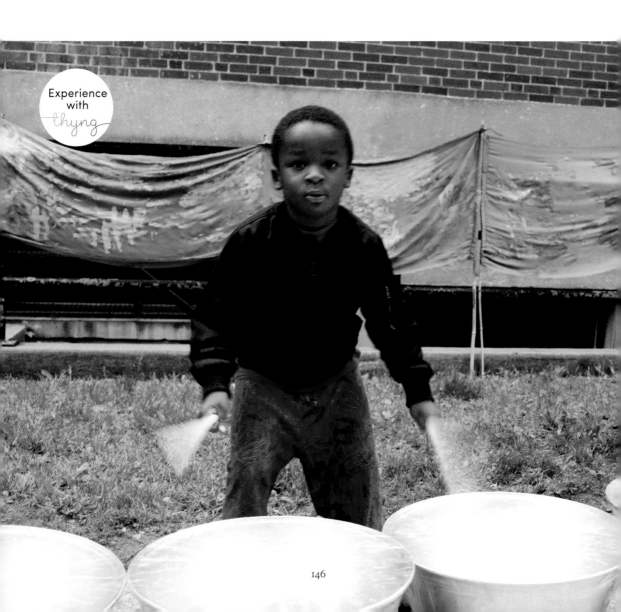

Experience with *thyng*

Alderman Carrie Austin

Jabberwocky Marionettes worked with the West Pullman Park Cultural Center to stage *The Savanna Arts & Music Parade*. Prior to the parade, the group held a series of classes where participants learned the history and stewardship of the natural savanna ecosystem found in the park, with costume-, puppet-, and music-making. The project is part of the broader initiative *The Re:Center Project: Cultivating Cultural Stewardship in Chicago's Parks*, a project of the Culture, Arts, and Nature Department of the Chicago Park District.

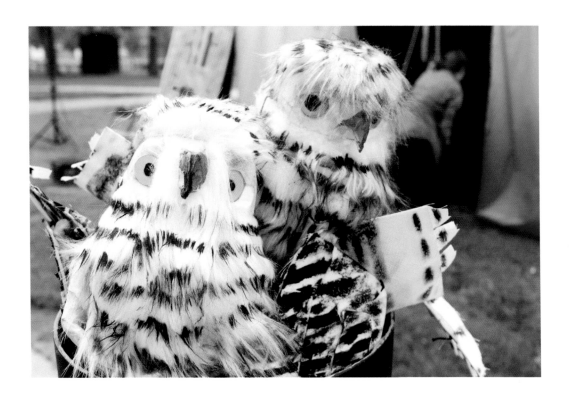

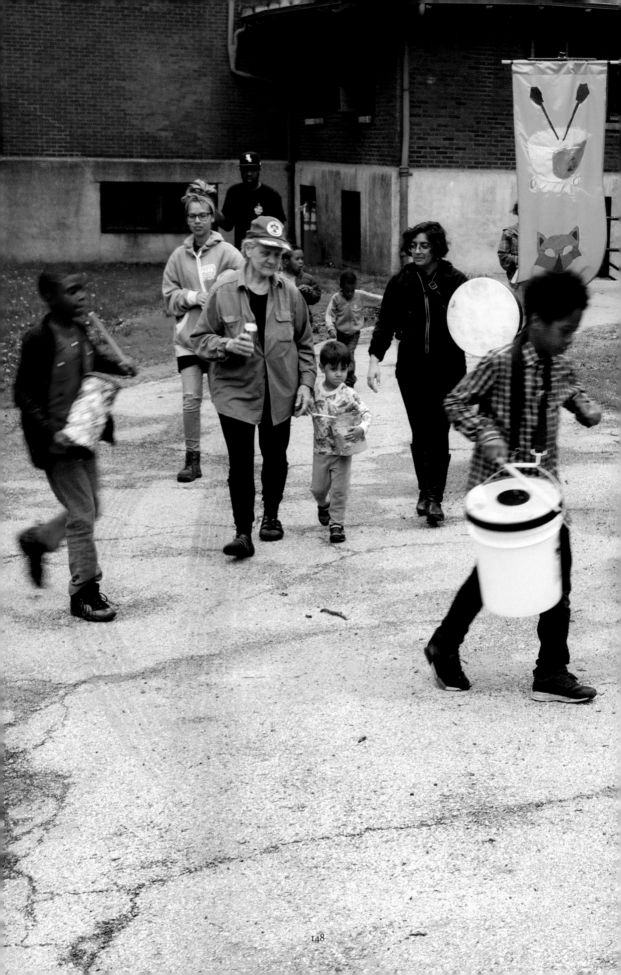

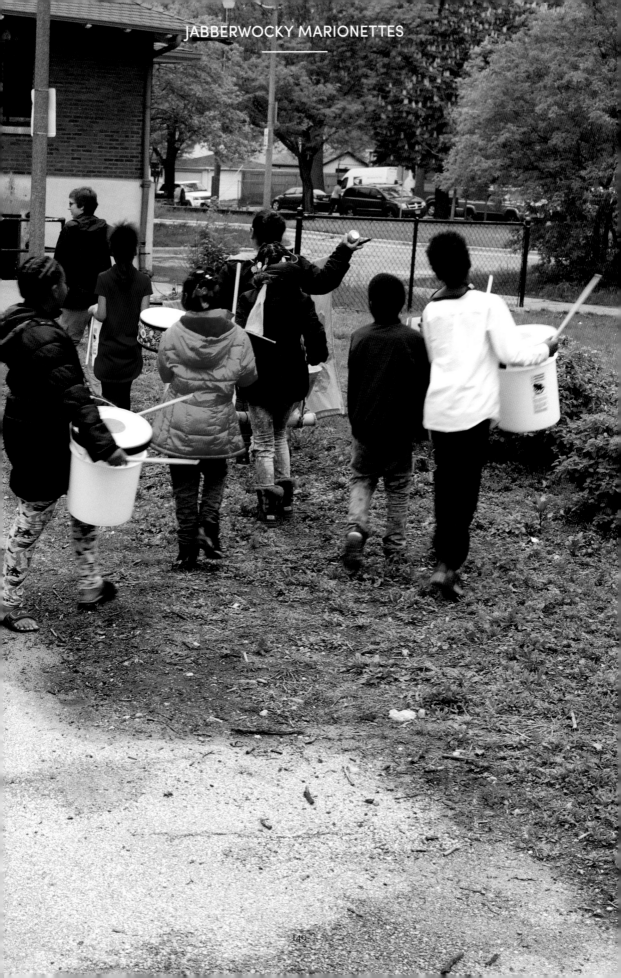

Sam Kirk and Sandra Antongiorgi

I Am Logan Square
Mural
Kedzie Avenue and Milwaukee Avenue

Experience with *thyng*

To create *I Am Logan Square*, Sam Kirk and fellow artist Sandra Antongiorgi, with assistance from Jenny Q., worked to understand what was important to community members. The large, vibrant mural asks residents to remember the past and consider the people and systems that create and define communities.

To read about Sam and Sandra's meeting with neighborhood youth, turn to page 230.

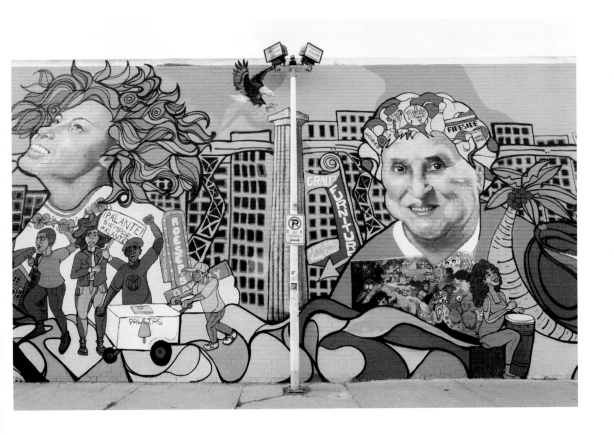

Barbara Karant

Seventy-Two Beats

Study for an installation

Community First Medical Center, 5645 West Addison Street

Seventy-Two Beats is a study for an urban intervention, a meditation on the essential connection between the City's health services and the people served. The study—what Karant refers to as an "architectonic iteration"—is a compilation of photographs of the architecture of the site, which, when recombined, generates a new incarnation of the space. The study is named for the function of the human heart, which beats 72 times per minute to circulate blood throughout the body.

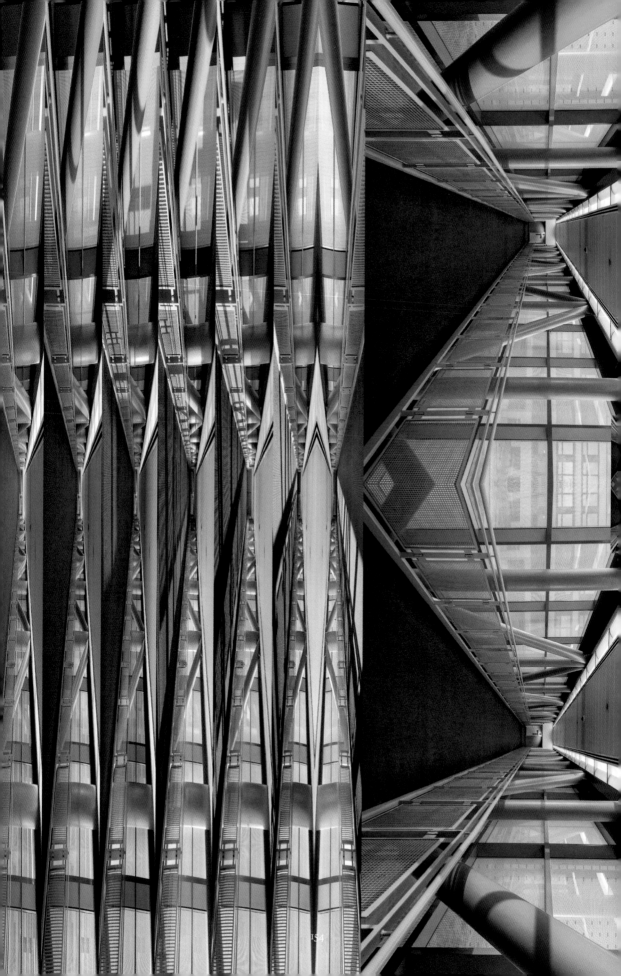

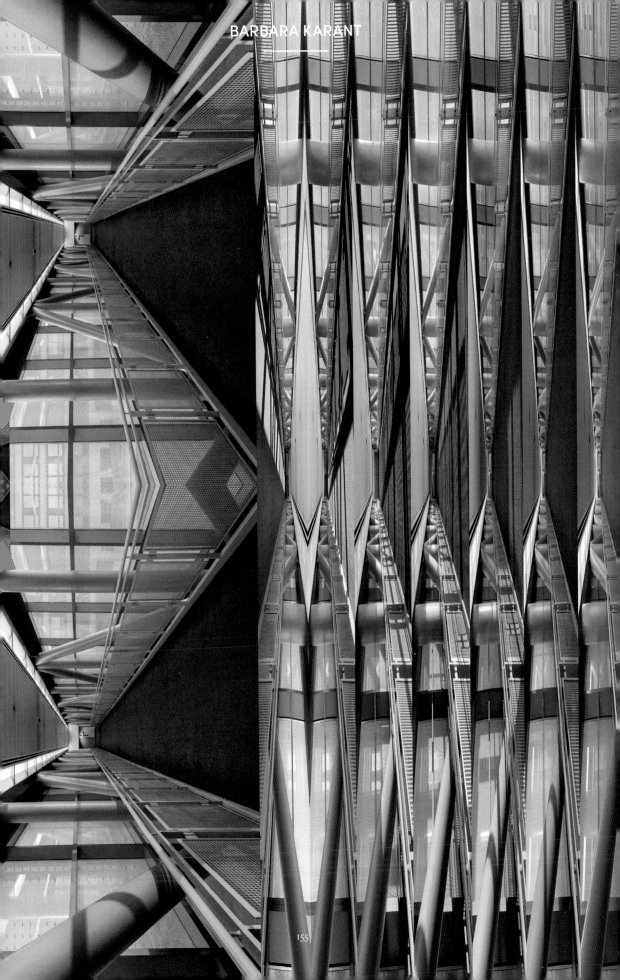

Industry of the Ordinary

Adam Brooks and Mathew Wilson

Disclaimer (over Chicago)
Performance
Messages flown over Chicago at dawn and dusk

History and Forgetting
Performance and installation
with Lindsey French, featuring Katinka Kleijn
Silent Funny, 4106 West Chicago Avenue

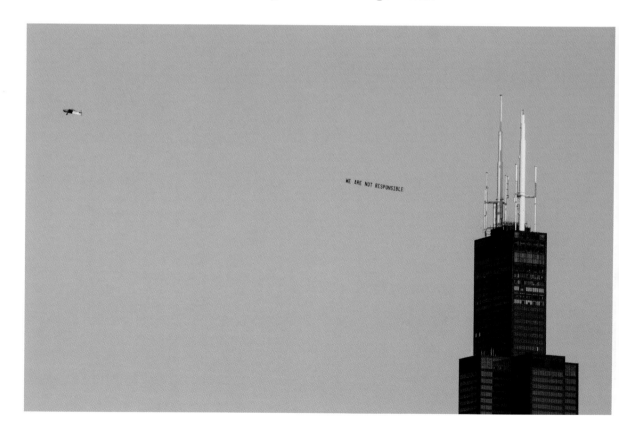

WARD 37

Alderman Emma Mitts

Inside Silent Funny's shop floor, two workers constructed a flag from ice blocks, which, as it melted, washed away the dust, oil, blood, and sweat that has stained the concrete floor over its years of use as a factory. Accompanying the melting flag were the voices of workers from the surrounding area. As the flag melted, a lone cellist, Katinka Kleijn, played the music of Anton Bruckner. The day's activities were framed by a small airplane towing a banner over the city of Chicago at sunrise and sunset. At sunrise the banner read: "WE ARE NOT RESPONSIBLE"; at sunset it read: "WE ARE RESPONSIBLE."

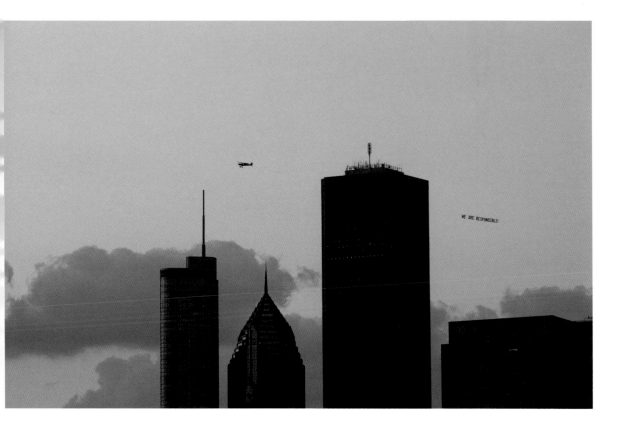

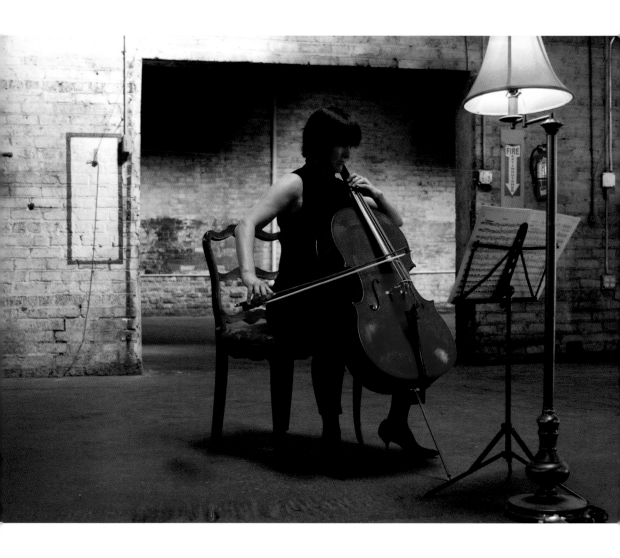

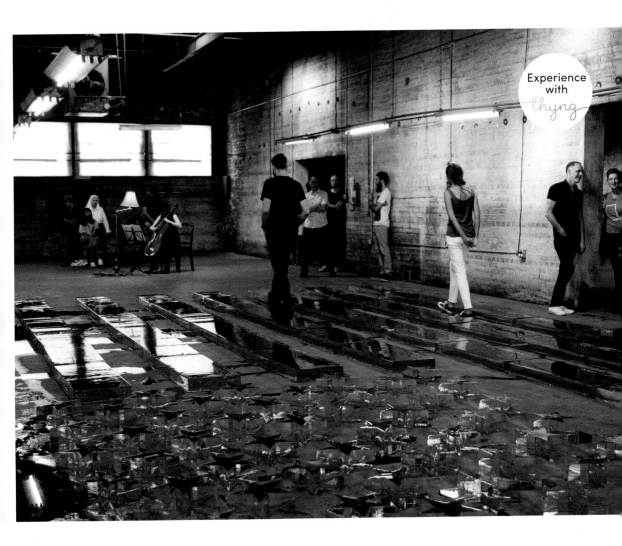

Dorrell Creightney

Remember Who We Are

Photographs

Union Pacific West Metra Line Viaduct, Kinzie Street and Laramie Avenue

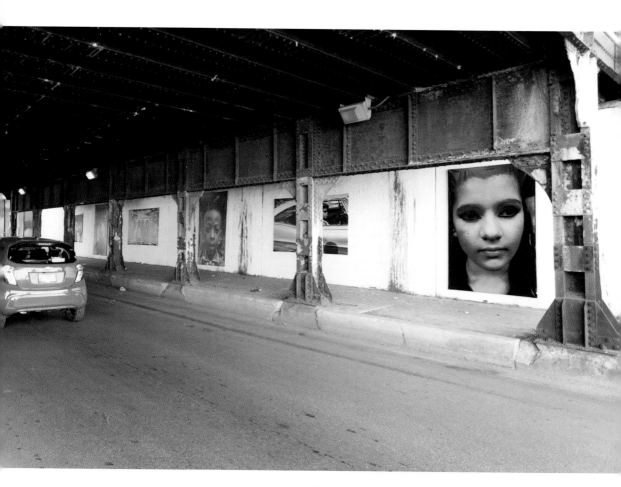

Remember Who We Are transforms the train viaduct's lower level into a gallery of photographs. The project was developed from the archive of late photographer Dorrell Creightney in cooperation with his family and Austin Coming Together, a community-building organization that focuses on quality of life. The life-size presence of Creightney's historical subjects communicates humanity and pure joy.

As a companion to the installation at Kinzie and Laramie, Creightney's images are also in the CTA Lightbox Art Project inside the Austin and Central Green Line 'L' stations. The lightboxes display a rotating selection of Creightney's photographic portraits, offering an intimate glimpse into the archive.

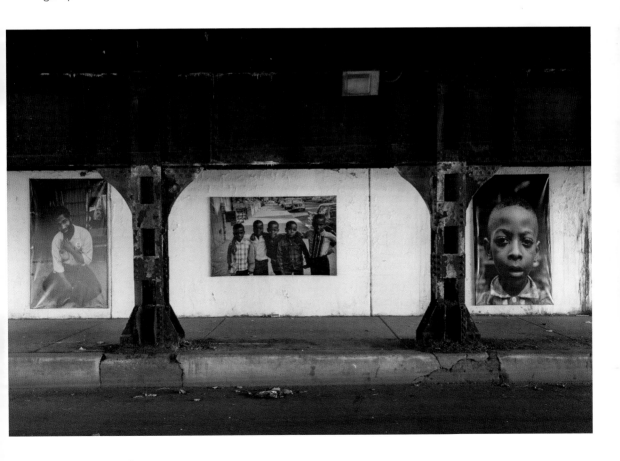

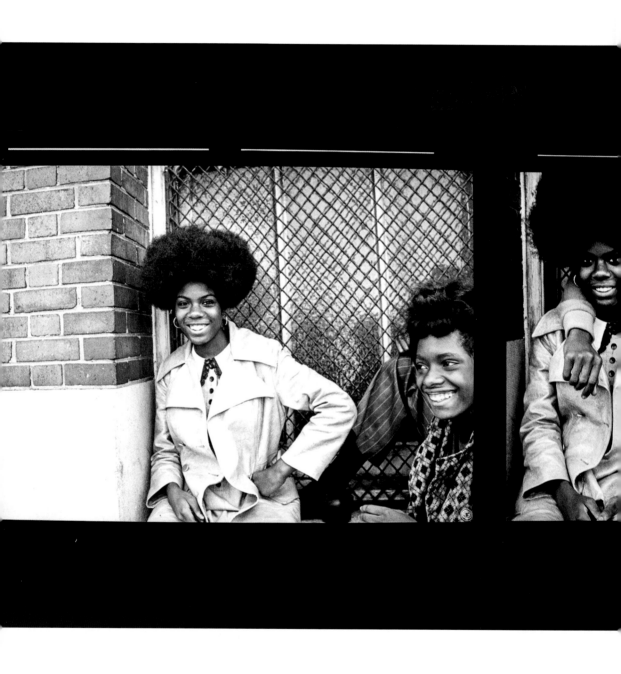

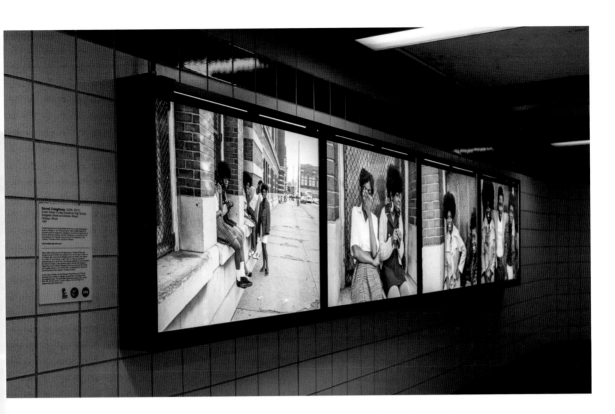

Arts Alive Chicago

Tony Passero

Feather Run

Mural

Chicago Park District, Merrimac Park, 6343 West Irving Park Road

Carma Lynn Park and Sara Peak Convery

38th Ward cART

Decal designs

Sites throughout the 38th Ward

Installed by Arts Alive Chicago from an original design painted by Tony Passero, *Feather Run* depicts two vibrant peacocks meeting in the center of a field of abstract symbols. It can be found on the east elevation of the Merrimac Park fieldhouse.

Throughout the ward you may also spot some of the 100 trash carts bearing decals designed by local artists Carma Lynn Park and Sara Peak Convery, whose designs were selected for their complimentary styles (one natural photography, one geometric painting).

38TH WARD cART **38TH WARD cART**

Carlos Matallana

Blok by Blok
Multimedia
Smyser Elementary School, 4310 North Melvina Avenue

Experience with thyng

Carlos Matallana began the *Blok by Blok* program with fifth graders at Smyser Elementary School. In this supplementary learning program for fourth, fifth, and sixth graders, students choose adults to engage in conversation. Matallana then teaches the students how to prepare for and conduct an interview. Equipped with research and conversational skills, the students seek out adult experts on the topics of their choice to learn firsthand through listening.

BJ
Krivanek

Shelter Here
Installations
Bus shelters:
5801 North Pulaski Road
4200 West Peterson Avenue
6100 North Cicero Avenue

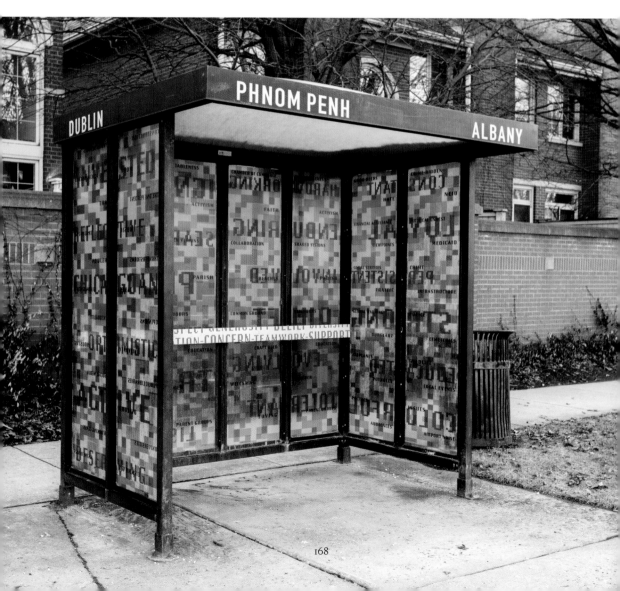

Shelter Here transforms an earlier style of Chicago bus shelter—one that evokes the simple lines and box-like forms of the city's iconic modernist architecture—into textual portraits that proclaim the survival and thriving collectivity of the 39th Ward within a transient cityscape.

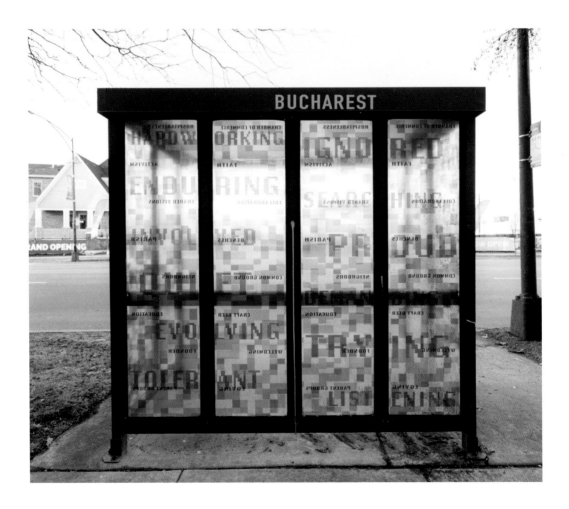

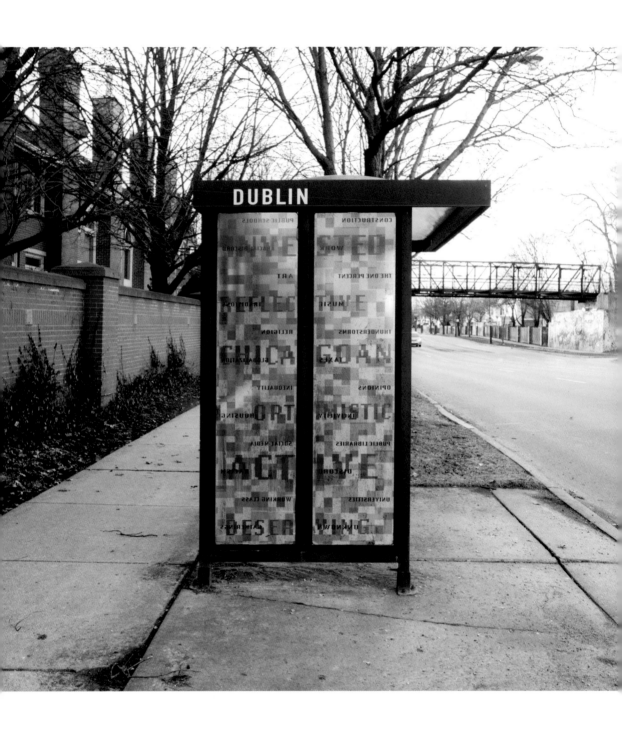

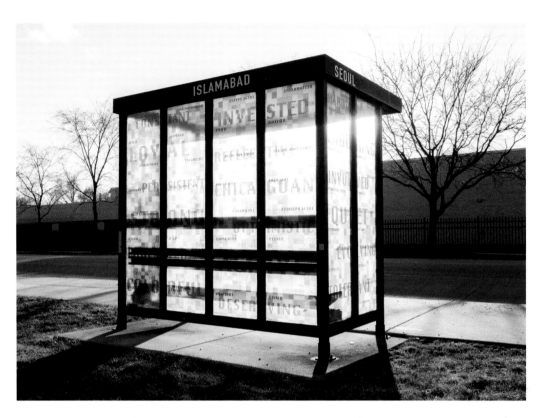

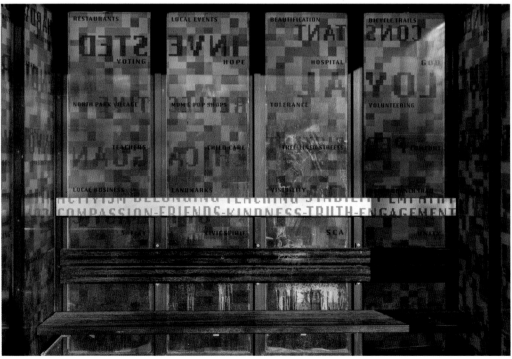

Green Star Movement

Tree Towers
Mosaic
Chicago Park District, West Ridge Nature Preserve, 5801 North Western Avenue

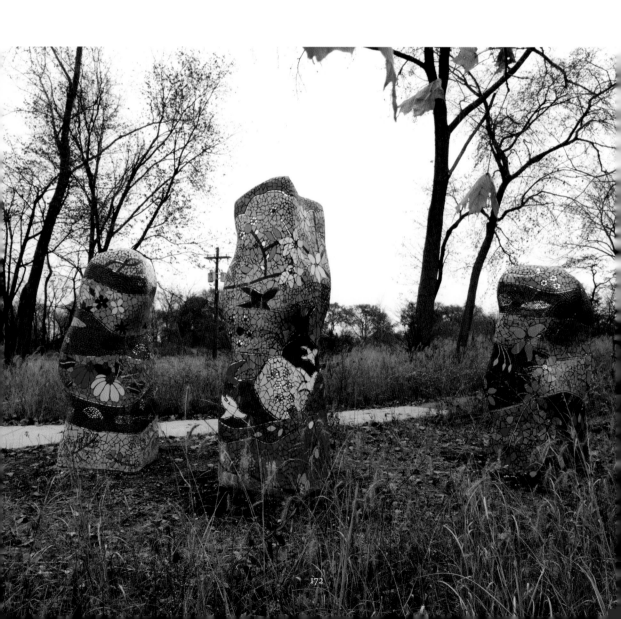

With the *Tree Towers*, Green Star Movement enhanced the native biodiversity of the West Ridge Nature Preserve, a sanctuary of 20 wooded acres near the busy intersection of Peterson and Western Avenues. Each tower is vertically divided into bands in which vibrantly patterned mosaic tiles depict the wildlife protected at the preserve.

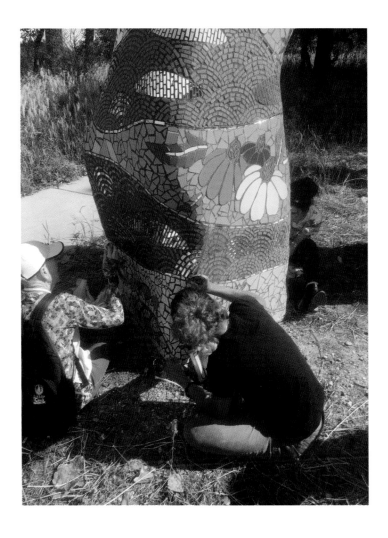

Mitchell Egly

Here & There
Mural
O'Hare Airport Bus Shuttle Center

WARD 41

Alderman Anthony Napolitano

Tasked with designing a unifying visual representation of the many neighborhoods that comprise the 41st Ward, Mitchell Egly created a mural that illustrates the neighborhoods—Norwood Park, Oriole Park, Edison Park, Wildwood, Edgebrook, and O'Hare Airport, its largest neighborhood.

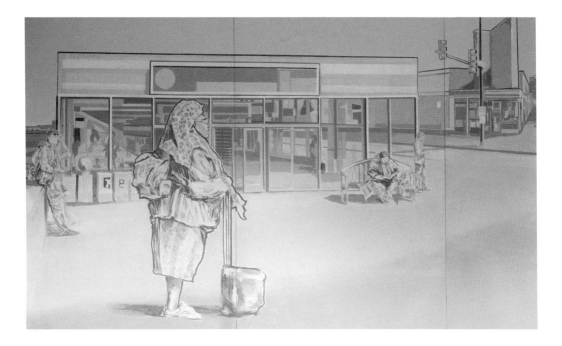

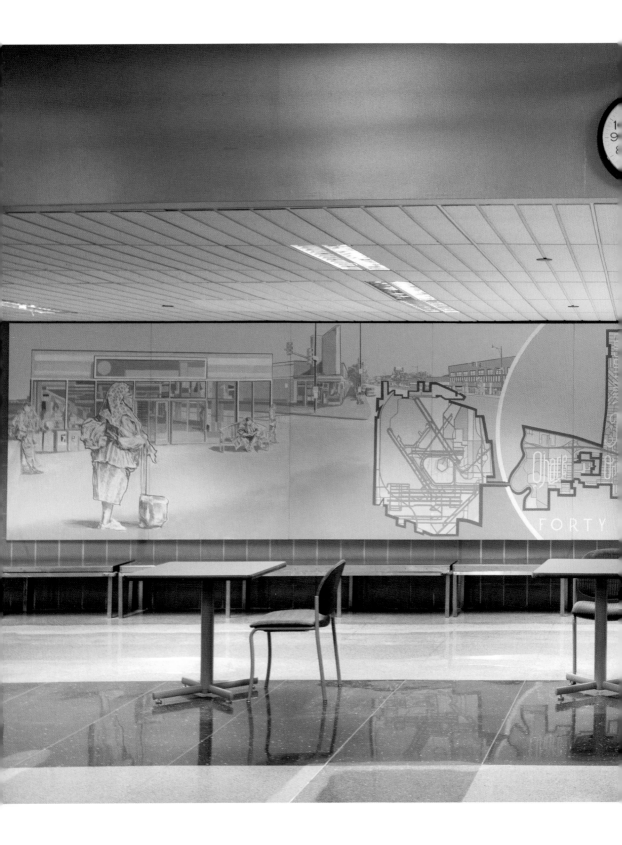

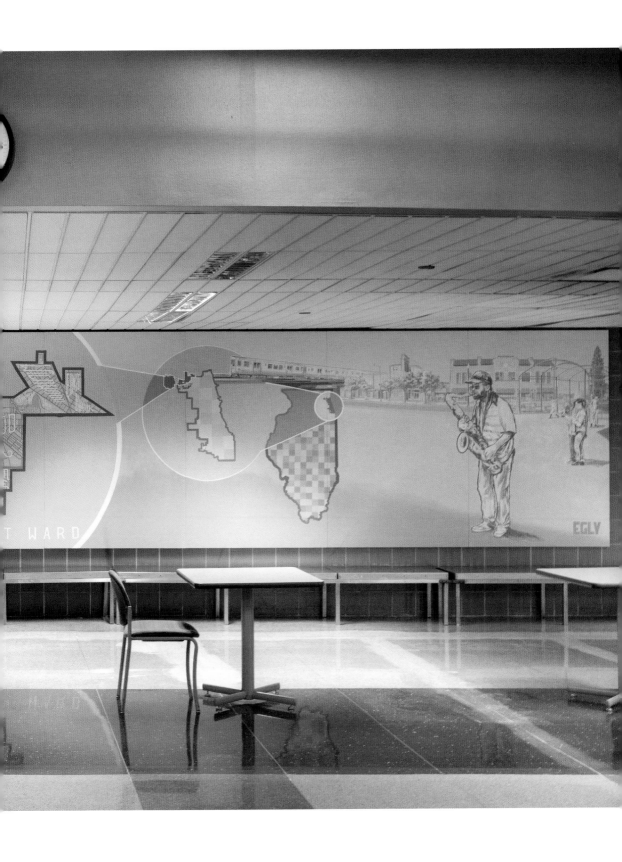

John Adduci

Loop Da Loop
Sculpture
"The Gateway to the Loop" micropark, State Street median at Lake Street

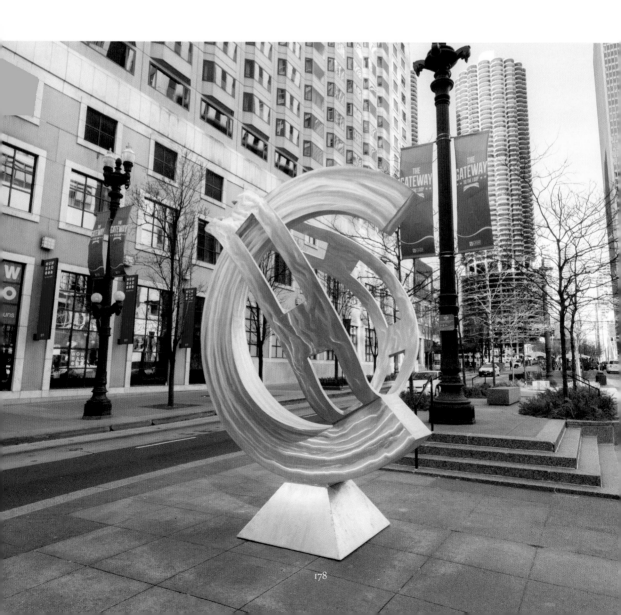

Loop Da Loop is a site-specific sculpture that draws inspiration from its location below the State and Lake elevated train station. Made of aluminum that echoes the material and structure of the metal elevated tracks, the sculpture intertwines this iconic symbol with a typographical "C" to represent Chicago.

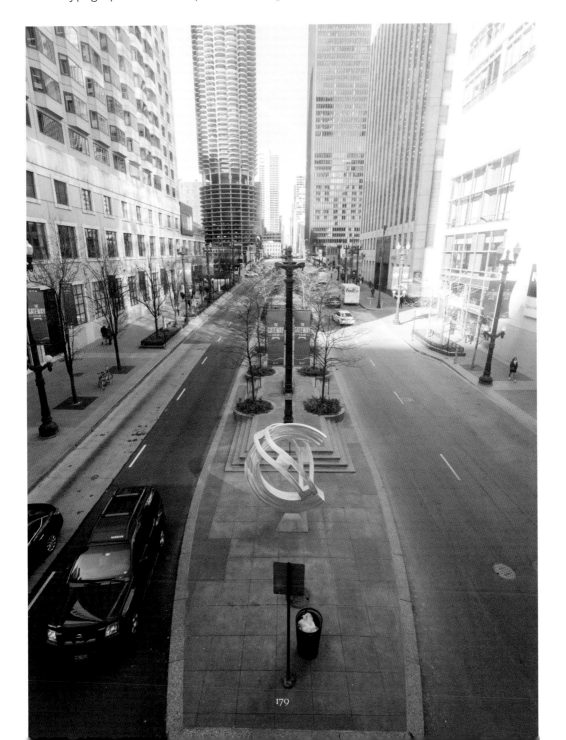

Candida Alvarez

Howlings—Soft Paintings
Temporary installation
Riverwalk, 112 East Wacker Drive

Candida Alvarez's mixed-media paintings combine abstract and figurative elements with pop-cultural references. After a collaboration with fashion designer Rei Kawakubo and Comme des Garçons, and a 40-year retrospective of her paintings at the Chicago Cultural Center, Alvarez employed a new approach to create her 200-foot mural. For this massive work anchored to the Wacker Drive structure above the Riverwalk, Alvarez pushed the limits of colors and vibrancy using an ink printer and then applied paint using large-scale brushstrokes, followed by the addition of glittery textures.

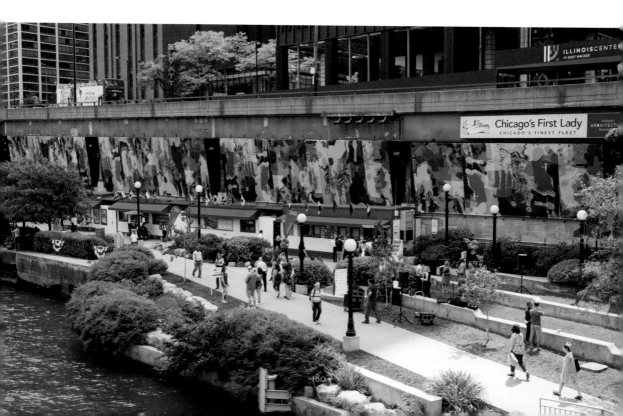

Tony Tasset

Deer

Temporary installation (no longer on view)
Riverwalk, between Franklin Street and Lake Street

Deer is a realistic, 12-foot-tall sculpture of a white-tailed doe made of painted steel and reinforced fiberglass. The lifelike dear, originally created in 2015, appears serene and vaguely interested in passersby. Tasset imbues the piece with a certain uncanny whimsy. However, *Deer* also generates a sense of surreal unbalance and hints at questions of humankind's own use of space, as well as our powerful impact on the environment. Standing next to a river that Chicagoans made to flow against itself, this piece turns the tables, dramatizing and making very physical our places in nature.

The Chicago Riverwalk is a 1.25-mile continuous walkway along the Main Branch of the Chicago River, which connects the lakefront to the urban fabric of the city. Located on the river's south bank, it has become a recreational destination and a site for public art installations.

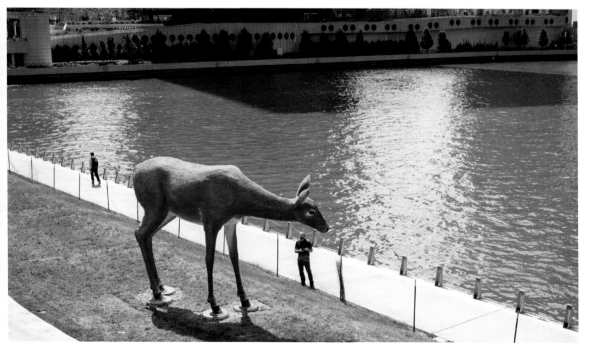

Isa
Genzken

Two Orchids

Temporary installation (no longer on view)

Chicago Park District, Buckingham Fountain Plaza, 301 South Columbus Drive

In *Two Orchids*, Genzken portrays a flower once rare and exotic, accessed only by royalty, which has now become ubiquitous in our global world. Its beauty also alludes to the perfect-looking, mass-produced fake flowers found in discount stores around the world. Genzken has said she is attracted to the "formal language of cheap materials and mass production. I'm not only interested in what they portray, but rather in the formal aspect of how they are made. And they come from all over the world: one component is from Taiwan, the next comes from Mexico, and the third from somewhere completely different."

Two Orchids was installed as part of Art Expo's 2017 IN/SITU Outside with the cooperation of David Zwirner Gallery, New York, in coordination with the Chicago Park District.

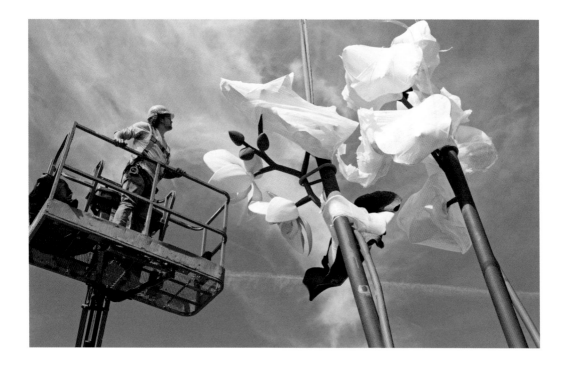

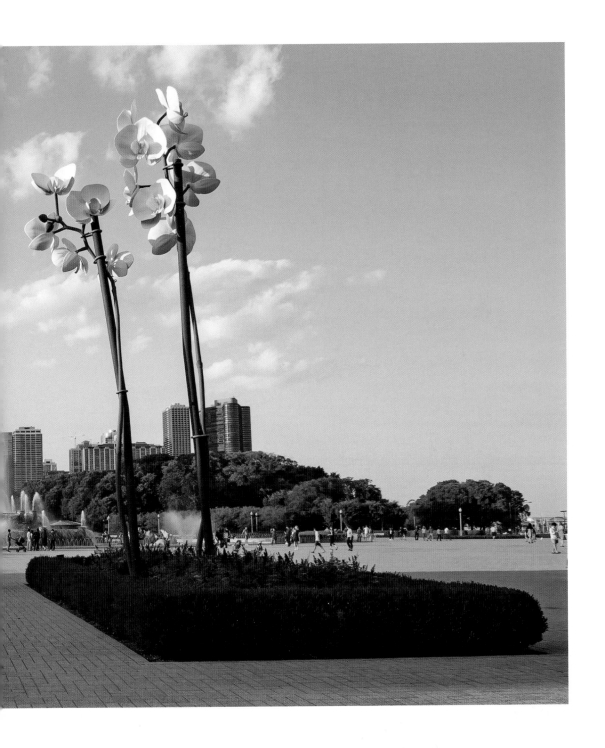

Kerry James Marshall

Rush More, 2017

Mural

Chicago Cultural Center, Garland Court façade, between Randolph Street and Washington Street

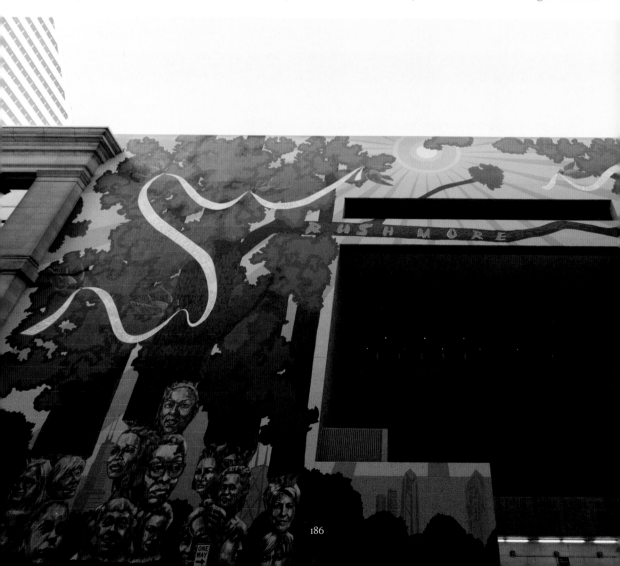

Rush More, by internationally renowned artist, MacArthur Fellow, and Chicagoan Kerry James Marshall, is the culminating artwork of Chicago's Year of Public Art. Marshall envisioned and designed the monumental mural—his largest work to date—to honor 20 women who have shaped Chicago's vibrant arts and cultural landscape. "In the history of monuments," Marshall said, "you have very few that represent women, but in the history of Chicago you have very many women that played key roles in establishing culture here. . . . My idea was to make a Forest Rushmore acknowledging the contribution of 20 women who've worked to shape the cultural landscape of the city, past and present."

Marshall's design for the mural was executed by Chicago artist and veteran mural painter Jeff Zimmerman, and appears on the west façade of the Chicago Cultural Center—a building at the center of Chicago's cultural community. In developing imagery for this intimate corridor, Marshall conceived a park-like atmosphere in which trees are totems. The likenesses of the honored women appear as carvings in the tree trunks, forming the foundations of towering pillars to support a lush canopy. The eye is drawn upward, past symbols of the iconic Chicago skyline, to a dazzling sky across which cardinals—the Illinois state bird, found throughout Chicago—thread a ribbon displaying each woman's name.

The cross-cultural, multi-generational list of women depicted in *Rush More* includes (from left to right): actress and cofounder of Dearborn Homes Youth Drama Workshop, Cheryl Lynn Bruce; Chicago Children's Theatre founder Jacqueline Russell; former first lady of Chicago and founder of After School Matters, Maggie Daley; founder of the DuSable Museum of African American History, Margaret Burroughs; founder and executive director of Little Black Pearl, Monica Haslip; television host and producer Oprah Winfrey; author, teacher, and Poet Laureate of Illinois, Gwendolyn Brooks; former Chicago Commissioner of Cultural Affairs, Lois Weisberg; actress, writer, and cofounder of Collaboraction Theater Company, Sandra Delgado; writer, translator, journalist and NEA Fellow, Achy Obejas; founder of eta Creative Arts Foundation, Abena Joan Brown; *Poetry* magazine founder Harriet Monroe; Black Ensemble Theater founder Jackie Taylor; founder and artistic director of Chicago Shakespeare Theater, Barbara Gaines; former executive director and chief curator of the Renaissance Society, Susanne Ghez; dancer and president of Muntu Dance Theatre of Chicago, Joan Gray; dancer, choreographer, and founder of Ruth Page Center for the Arts, Ruth Page; writer, NEA Fellow and National Medal of Arts recipient, Sandra Cisneros; artist and cofounder of the AfriCOBRA artist collective, Barbara Jones-Hogu; founder and artistic director of Project&, and founding director of the Ellen Stone Belic Institute for the Study of Women and Gender in the Arts and Media, Jane Saks.

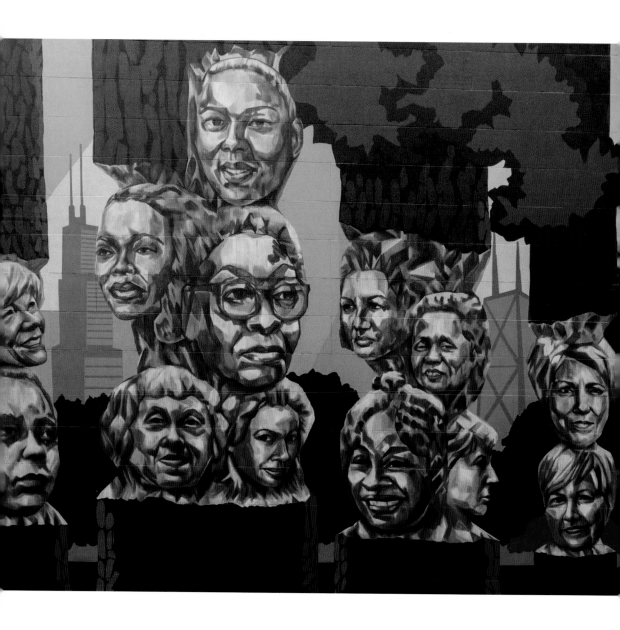

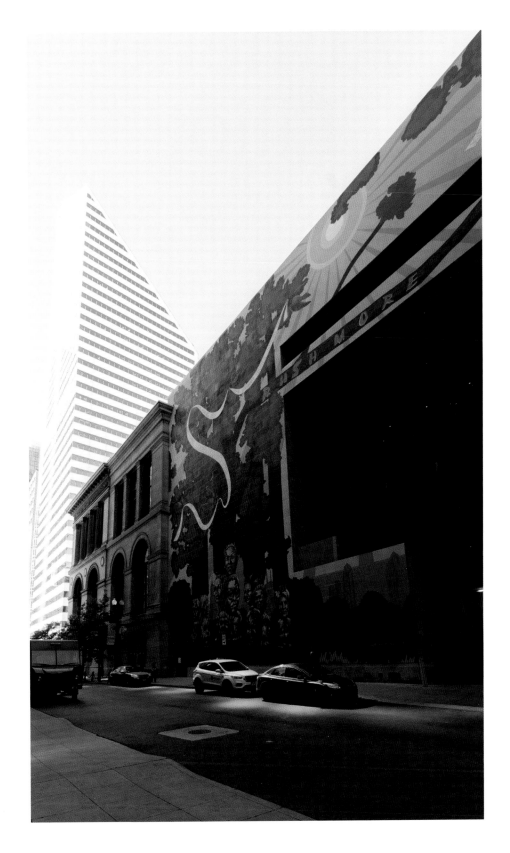

Annette Elliot

Prehistory

Temporary installation

Intersection of Halsted Street, Lincoln Avenue, and Fullerton Avenue

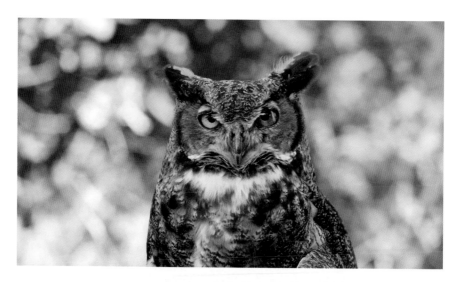

Prehistory is an ephemeral video projection. At dusk nocturnal birds—the great horned owl, the eastern screech owl, the barn owl—appear and disappear on the brick wall surface. The immersive video projection invites viewers to experience familiar places anew, revealing the city as a complex ecosystem.

Steven Carrelli

Armitage Ghost Mural

Mural

939 West Armitage Avenue

Armitage Ghost Mural evokes the architectural identity of the Armitage-Halsted Landmark District. Its materials and design reference the neighborhood's history as one of Chicago's first-generation commercial districts.

To read about Steven Carrelli's experience of painting, go to page 236.

Ruben Aguirre

Untitled
Mural
Division Street at Lakeshore Path

The visceral experience of descending into the pedestrian tunnel at Lake Shore Drive and emerging at the waterfront is captured in this mural, but instead of replicating a lakefront scene, Aguirre translates its impression into abstract design elements.

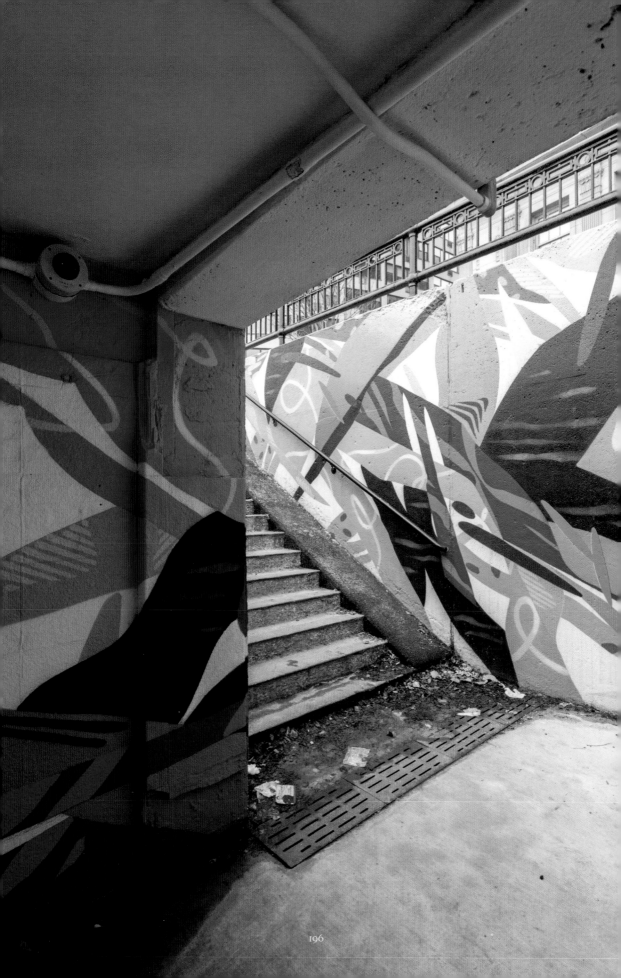

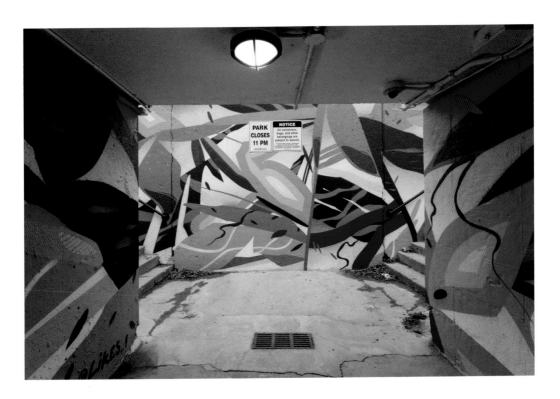

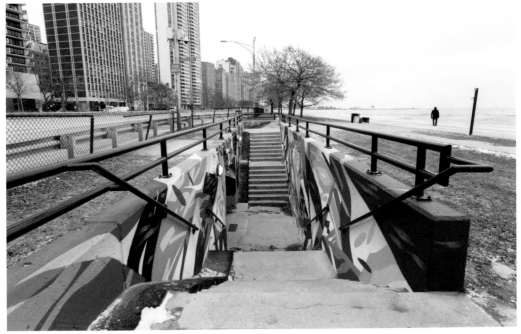

Sandra Antongiorgi, Andy Bellomo, and Sam Kirk

The Love I Vibrate
Mural
Howard Brown Health Center, 3245 North Halsted Street

Located at the Howard Brown Health Center, the mural features an image of holistic healer and interdisciplinary artist Kiam Marcelo Junio, and pays tribute to the countless artists, hard-working activists, healers, teachers, leaders, and queers who work to bring the community together.

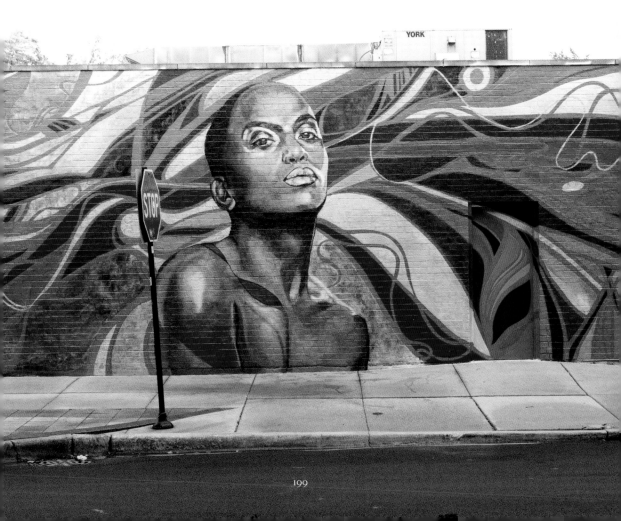

Sentrock

Southport Style
Temporary installation
3410 North Southport Avenue

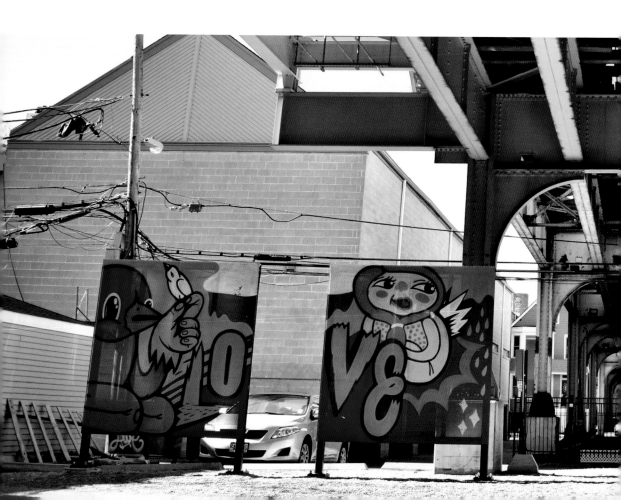

Sentrock drew inspiration from the streets of Lakeview to create *Southport Style*, which depicted his characters riding the train, biking, and admiring flowers. Created as part of the Lakeview Low-Line project, which re-envisions the half-mile space beneath the CTA 'L' tracks between Southport and Lincoln Avenues as an exciting art destination and a dynamic path connecting the Lakeview neighborhood, this temporary installation spanned four walls that host rotating murals.

Various chambers of commerce and SSAs worked closely with DCASE on a number of *50x50* artworks. Others drew from the *50x50 Neighborhood Arts Project*'s prequalified artist list to create additional works. This example, from the Lakeview Chamber of Commerce, was funded by SSA 27 as part of the Lakeview Public Art Initiative, which aims to create more regular and district-wide public art in the Lakeview neighborhood.

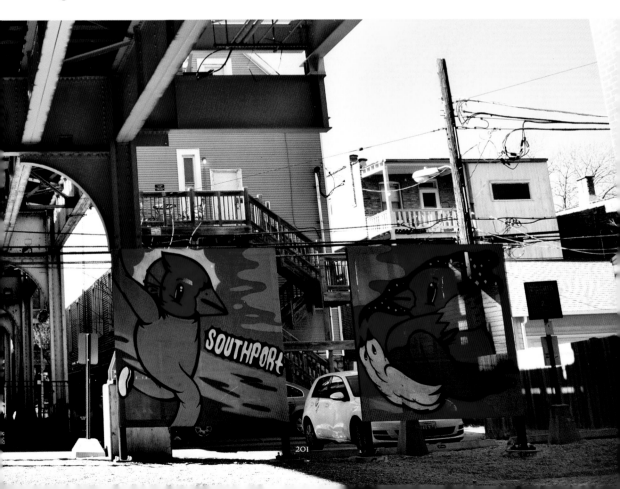

Bernard Williams

Volga

Sculpture

Intersection of Foster Avenue, Milwaukee Avenue, and Central Avenue

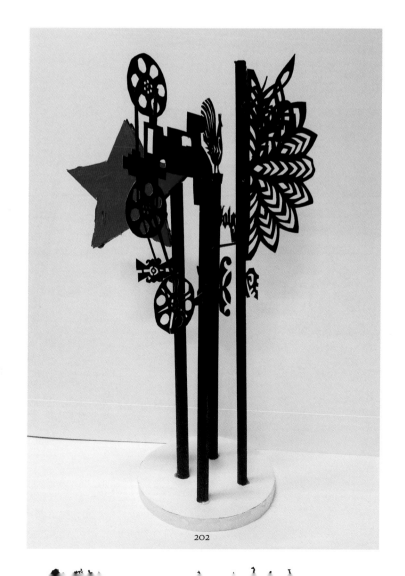

To develop his concept for *Volga*, Bernard Williams, through Alderman Arena, reached out to local historians and key figures in the neighborhood. They helped him scout out the neighborhood's historical and architectural artifacts, including an iconic star from the now closed Red Star Inn restaurant. To contribute to the work, Alderman Arena's office organized neighbors to donate local, weather resistant, outdoor objects such as railings, fences, and gates. These fragments were ultimately incorporated into the design of the sculpture, providing a visual shorthand for the collective memories of the community.

Lucy Slivinski

Phoenix Rising
Sculpture
Intersection of Sheridan Road, Broadway, and Montrose Avenue

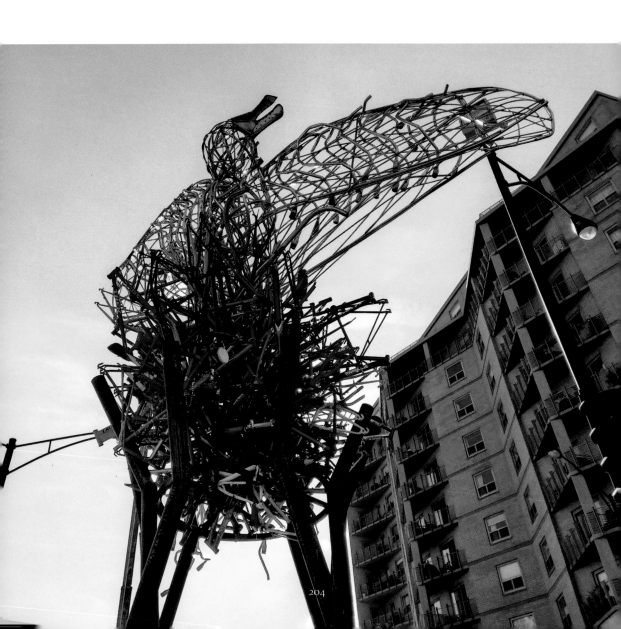

Alderman James Cappleman

Phoenix Rising is a symbol of rebirth. Using recycled materials, Slivinski gathered scrap materials from a nearby Chicago Transit Authority Red Line improvements project site. To contribute to the work, Alderman Cappleman's office organized Uptown neighbors to donate bicycles, pipes, and other scrap metal. The artwork stands as a welcoming beacon and marks the entry to Uptown at its southern boundary.

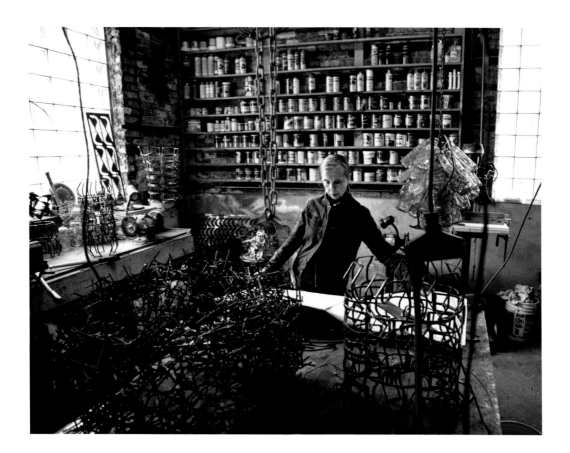

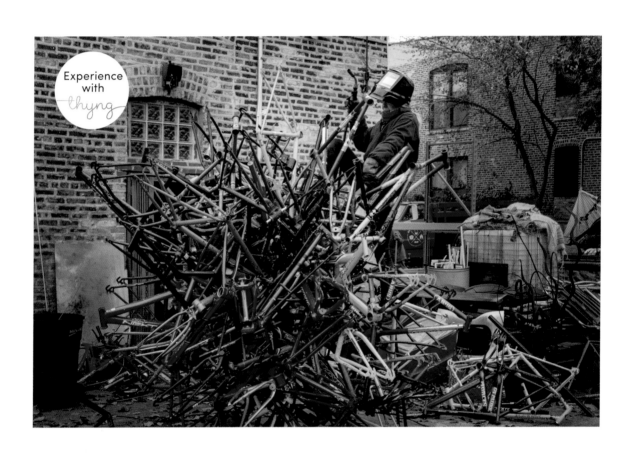

Experience with thyng

206

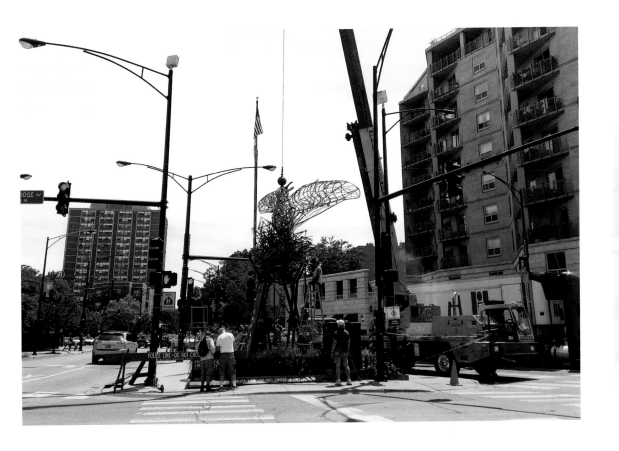

Allison Svoboda

Helical Om
Sculptural installation
Northcenter Town Square, 4100 North Damen Avenue

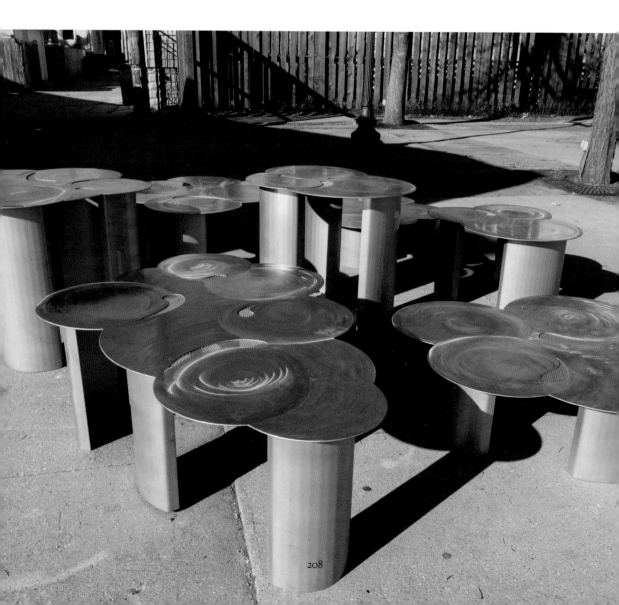

Helical Om presents overlaid circles of stainless steel to create cloudlike forms that function as chairs and tables. Their organic shapes, including water drops incised in the steel, suggest the natural environment. This work will be integrated into a larger redevelopment of the plaza spearheaded by PORT Urbanism.

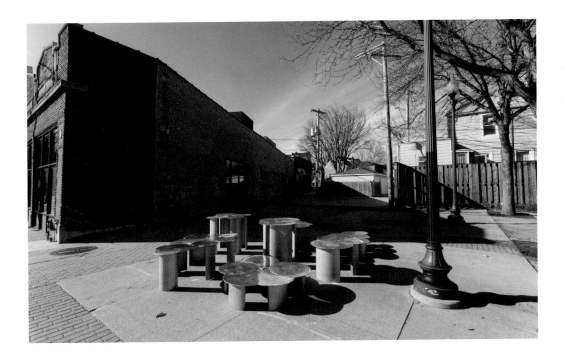

Anthony Lewellen

LAKE VIEW

Mural

Intersection of Lincoln Avenue, Ashland Avenue, and Belmont Avenue

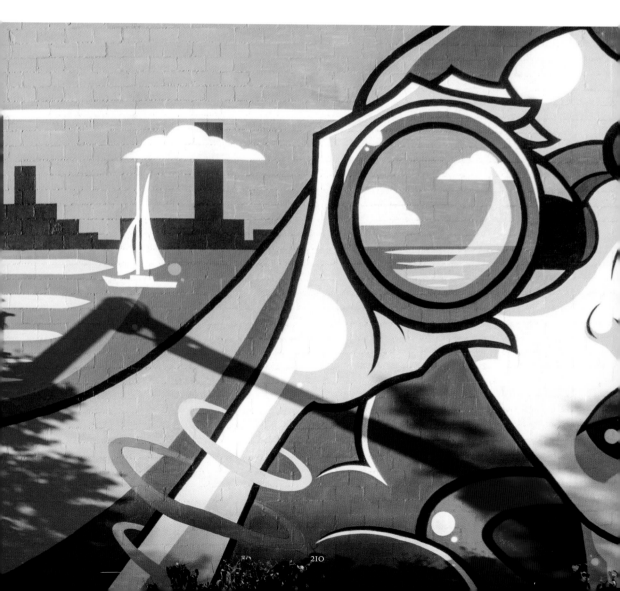

LAKE VIEW celebrates Lakeview at an intersection that serves as the geographical center of the neighborhood. According to Lewellen, who grew up in Lakeview and has been a prominent figure in the Chicago arts community for decades, "The central female figure, her hair flowing like waves, towers above the surrounding trees and buildings and in her reflected gaze, we see the horizon clear, blue, open, and full of possibilities."

Various chambers of commerce and SSAs worked closely with DCASE on a number of *50x50* artworks. Others drew from the *50x50 Neighborhood Arts Project*'s prequalified artist list to create additional works. This example, from the Lakeview Chamber of Commerce, was funded by SSA 27 as part of the Lakeview Public Art Initiative, which aims to create more regular and district-wide public art in the Lakeview neighborhood.

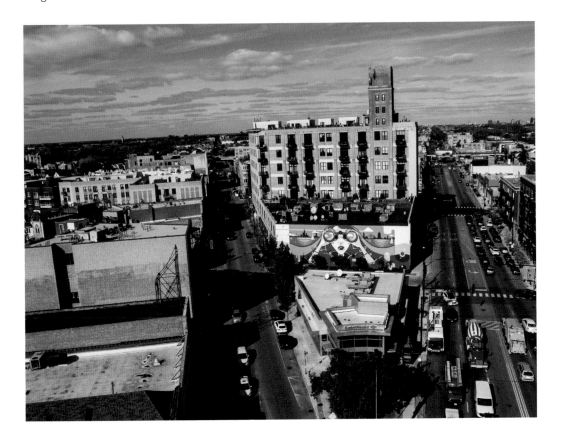

Erik Peterson

Ashland
Sculpture
Thorndale Avenue, between Sheridan Road and Lane Beach

Ashland is a both a sculpture and a utilitarian piece of urban furniture installed within a median at the eastern end of Thorndale Avenue, where the city meets the lake. It was constructed from the wood of blighted ash trees affected by the emerald ash borer and removed from Rutherford Sayre Park on Chicago's northwest side. It allows people to sit, relax and contemplate, taking in the view of the water and park.

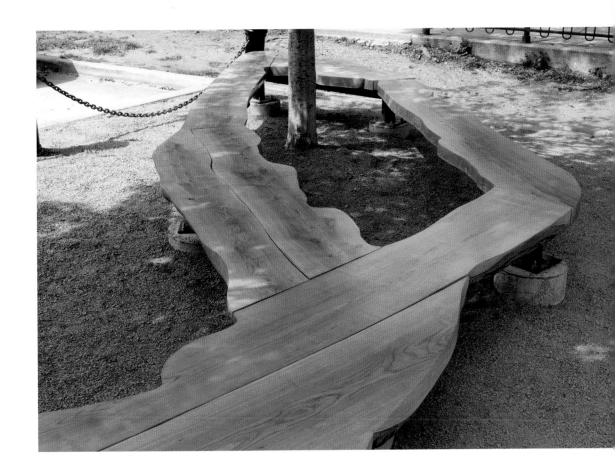

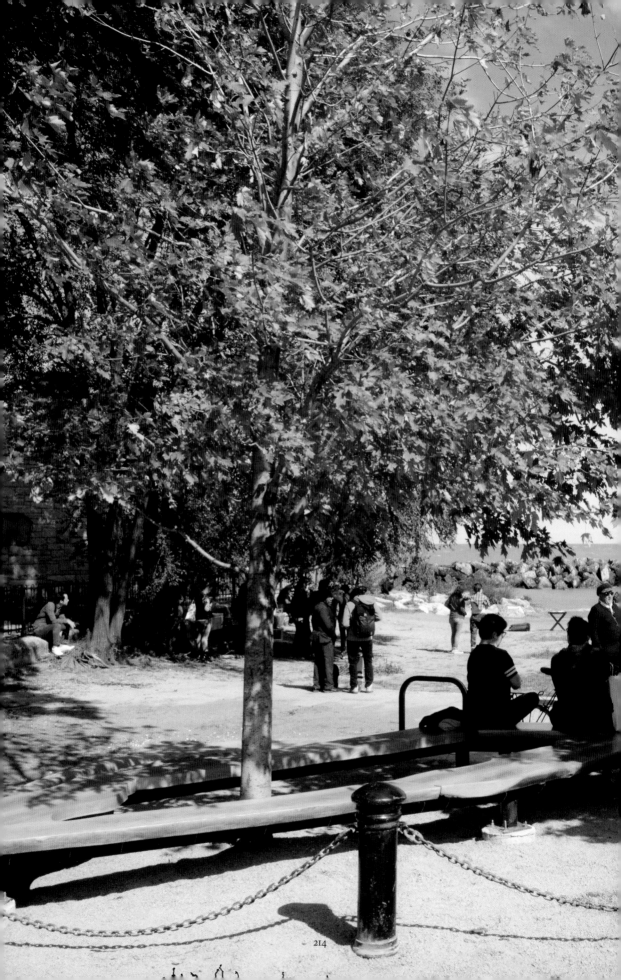

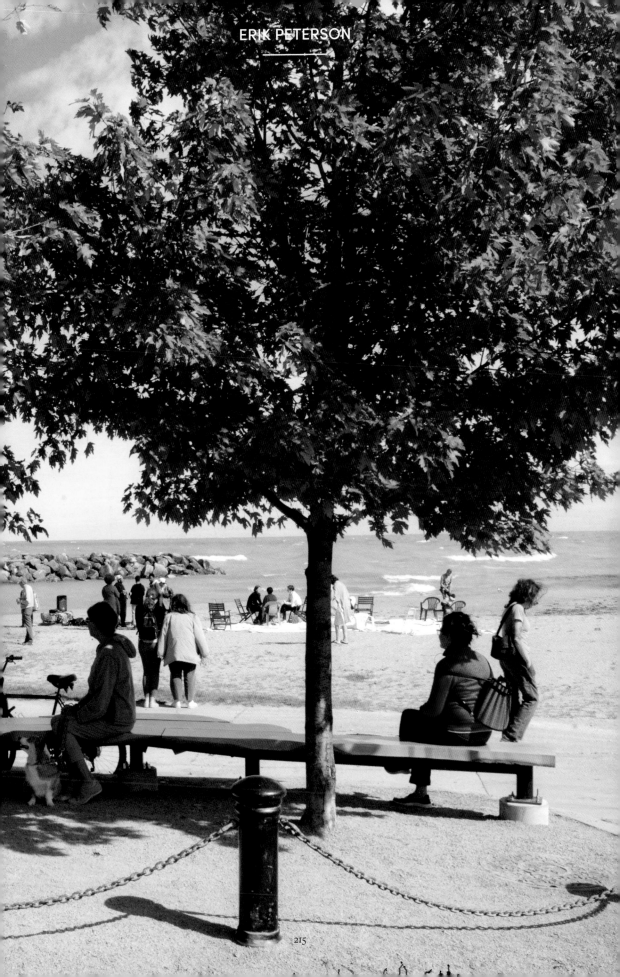

Cheryl Pope

Hear I Am

Installation

Chicago Park District, Broadway Armory Park, 5917 North Broadway

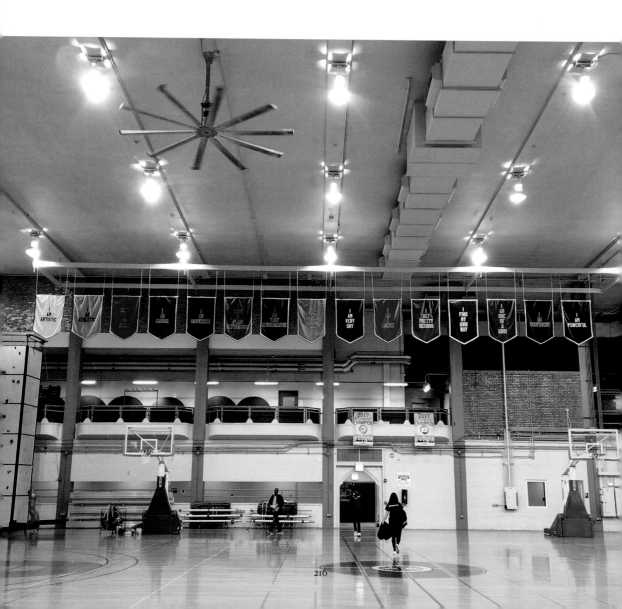

Hear I Am consists of championship banners that display the voices of Edgewater inside and outside of the Broadway Armory fieldhouse. Pope's banners maintain a pendant shape, varsity font, and team colors, but the sports titles are replaced with individual poetic texts gathered from local youth and seniors who recreate at the park.

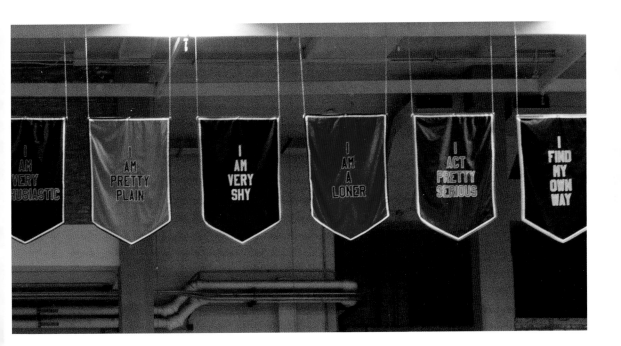

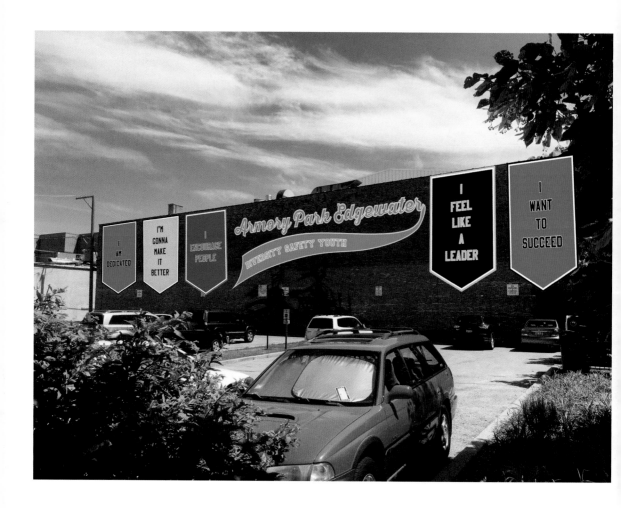

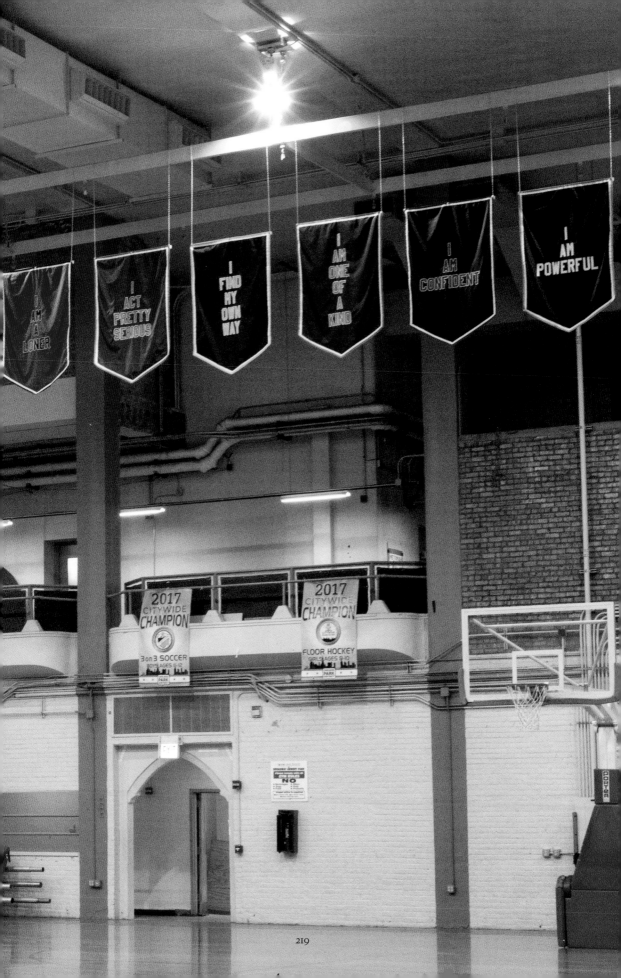

Thomas Houseago

Large Walking Figure 1
Temporary installation
Chicago Park District, Grant Park near Foster Beach

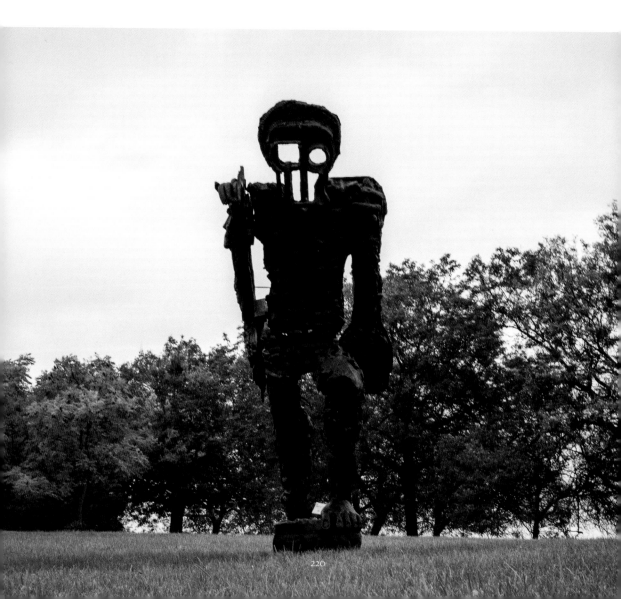

Alderman Harry Osterman

Seeming to climb a hill near the Lakefront Trail, this massive skeletal figure is angled to indicate the exertion of each step and creates the appearance of flesh merging with machine. Houseago leaves the armature and structural components visible, allowing the viewer to "feel the process" of sculpting.

In 2017, the Chicago Park District installed 52 new works of public art in more than 40 parks across the city, some of which were part of the *50x50 Neighborhood Arts Project*.

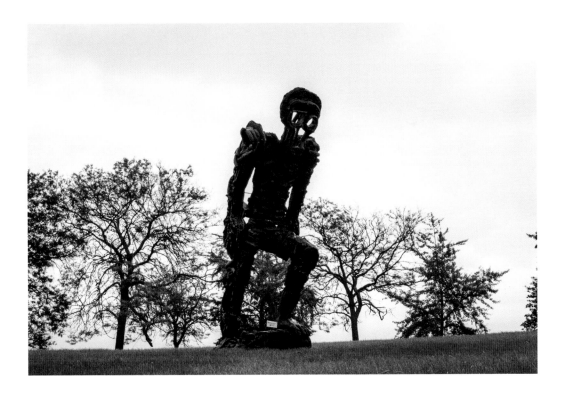

Davis McCarty

Quantum Dee

Sculpture

Chicago Park District, Juneway Terrace Park, 7751 North Eastlake Terrace

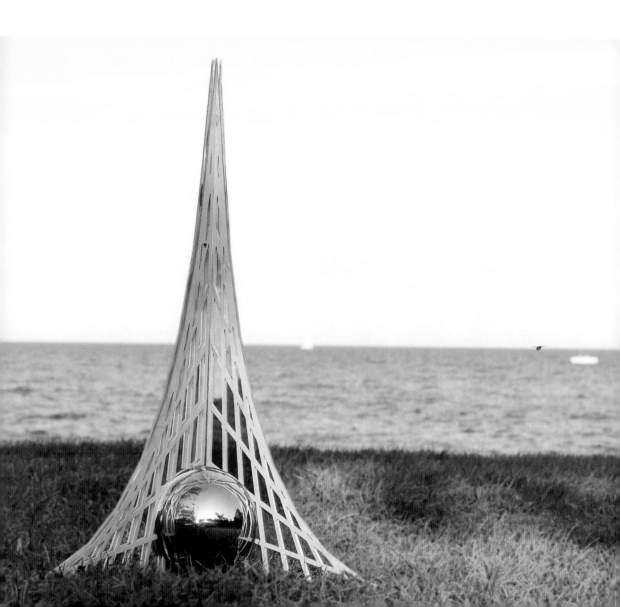

Alderman Joseph A. Moore

Davis McCarty's *Quantum Dee*, located in the Rogers Park neighborhood, features a stainless steel globe integrated into a dichroic plexiglass spire. Located at the northern-most beach in Chicago, *Quantutm Dee* reflects horizontal surfaces—stretches of grasses, water, and the lake's horizon line.

Note: *Quantum Dee* works in symmetry with McCarty's Sculpture, *Quantum Me*, in the 19th ward (see page 94).

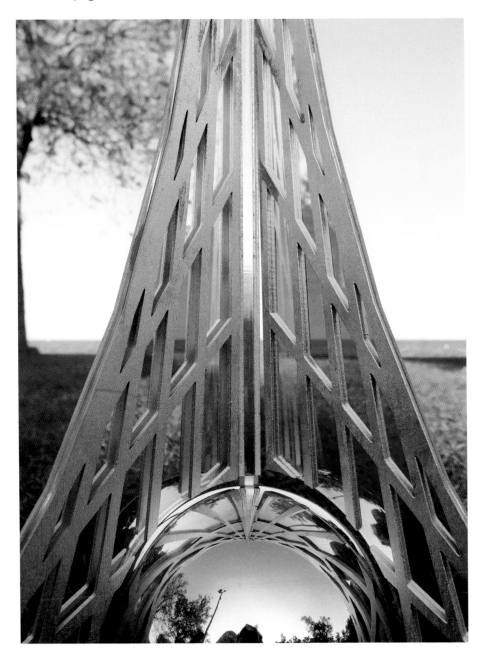

Brandon Breaux

Takashi Murakami
Virgil Abloh
Kerry James Marshall
Lightboxes
Chicago Transit Authority, Loyola Red Line Station, 1200 West Loyola Avenue

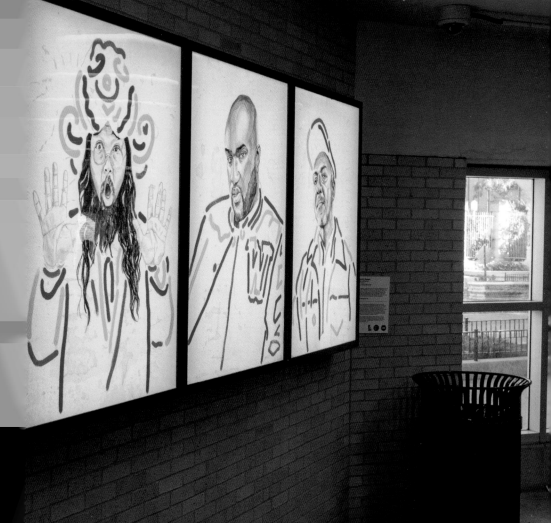

Brandon Breaux created a triptych of three living artists whom he admires and who have risen to the pinnacle of their creative professions—Takashi Murakami, Virgil Abloh, and Kerry James Marshall. Breaux unifies their images with a nod to pop art, framing them in loose bright lines of blue, red and yellow.

Takashi Murakami merges commercial production and fine art, developing the term "superflat" as a description of both his work and a broader aesthetic movement in post-war Japan influenced by 2D anime and manga comic culture. The son of Ghanaian immigrants, Virgil Abloh is a Chicago-based fashion designer, music producer, leader of the Milan clothing label Off-White, and artistic director at Louis Vuitton. Chicago artist Kerry James Marshall is known for large-scale paintings that situate contemporary African American subjects in dialogue with art historical precedents.

During the Year of Public Art, the Chicago Transit Authority (CTA) partnered with DCASE to create the CTA Lightbox Art Project, with lightbox installations in train stations, highlighting the perspectives of Chicago artists and neighborhoods.

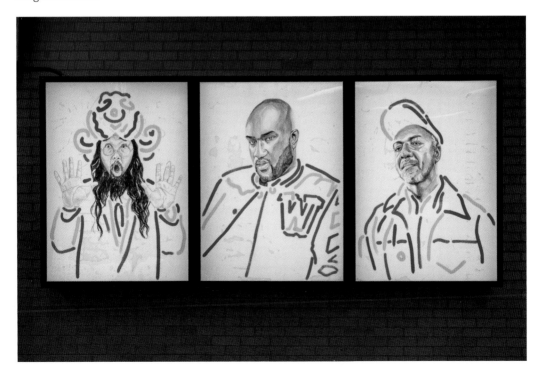

Architreasures
with Bernard Williams

Screen Cloud

Sculpture

Chicago Park District, Bernard Stone Park, Devon Avenue and McCormick Boulevard

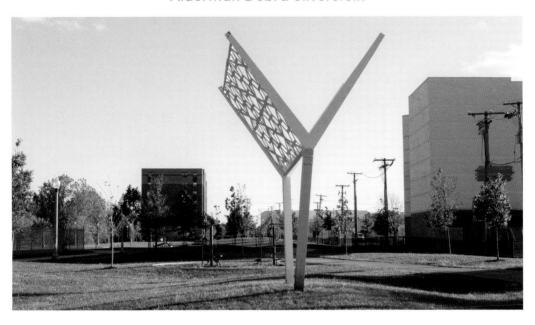

Reflecting on conversations with community and cultural groups in the neighborhood, *Screen Cloud* takes inspiration from nonrepresentational, ornamental traditions in architecture, carpets, ceramics, jewelry, metal works, and textiles found in the Middle East and North Africa.

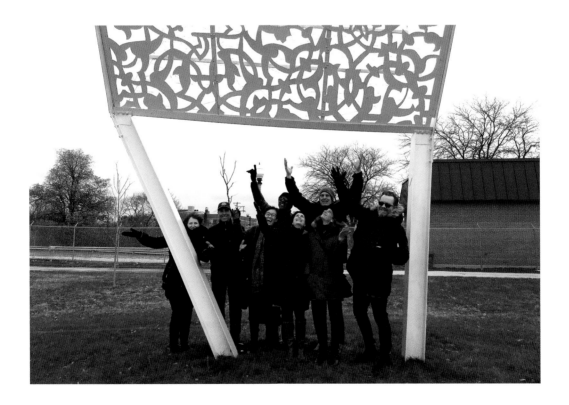

50x50

Community Engagement

At the heart of the *50x50 Neighborhood Arts Project* are the artists and their connections with neighborhoods. The following texts—notes from responses to questions posed by artists Sam Kirk and Sandra Antongiorgi to a group of youth in the Logan Square/Hermosa Park neighborhood, and Steven Carrelli's personal opinions about making a work of art in public—highlight two forms of community engagement and the artists' commitments to capturing the essence of the neighborhoods in the resulting work.

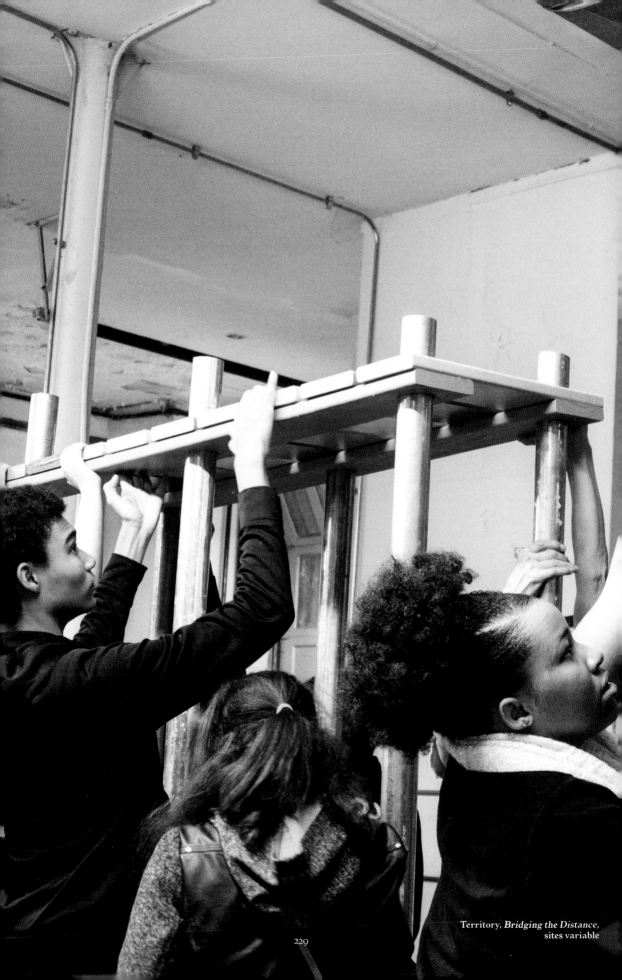

Territory, *Bridging the Distance*,
sites variable

Community Engagement

Sam Kirk and Sandra Antongiorgi

Both Sandra and I regularly engage community members or groups when developing murals. When I met with Alderman Carlos Ramirez-Rosa and team, I suggested having a Q&A with community members to have a conversation about Logan Square as my approach to developing the design. Once they awarded me the project, I brought Sandra on board and we developed the series of questions together.

For this project the Alderman's office requested that we work with youth, and they recruited several community organizations: HairPin Arts, LSNA, Voices for Children, and Segundo Ruiz Belvis.

It is important to have conversations with a wide variety of people in the community when developing a concept, as their feedback and stories often help to shape the direction that we take for the mural concept. Working with the youth in Logan Square helped us to learn how the changes in the community are impacting their lives and how this affects their future.

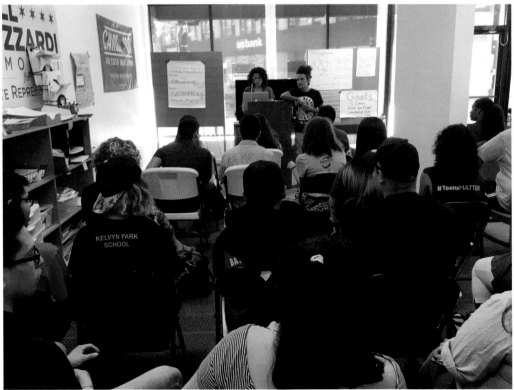

Questions and Youth responses from Logan Square/Hermosa Park meeting at Alderman Carlos Ramirez-Rosa's office before developing the 35th Ward mural

What are your favorite places in your community?

- The Eagle
- Murals around Liberty (from train) between California going down thru Mega Mall
- Prairie garden—very pretty
- The Mega Mall—majority grew up going there. Has a lot of history. All family would go there for affordability, book bags, school supplies.
- Cos Park—soccer field. Friendly, immigrants. Being torn down. Lots of families leaving. Flea market burned down, Mega Mall being torn down "leaves a hole in our heart." Seeing the hard work of our families . . .
- Enjoyed the graffiti on Mega Mall wall
- Tearing down of Mega Mall showed impact of gentrification; Latinos being pushed out. Unfair to families (black and brown).
- Avondale—has new builds next to raggedy houses. Seeing that hurts me. Knowing it's happening in my own neighborhood sucks. Not the same community. All white people.
- Not present anymore? The youth. Now adults sitting there drinking wine. Corner grocery stores are gone. Now it's bars, fancy restaurants. Neighborhood is outspoken.
- Neighbors use to keep an eye out on neighbors. They used to talk. Families knew one another. Now no one talks. No one knows their neighbor.
- Community Gardens. Families garden peppers, tomatoes—despite density. There's a lot of food, fresh food being grown, hidden community gardens. Even personal gardens [in back yards]. Altgeld/Sawyer.
- St. Sylvester Church—neighborhood church
- Café con Leche
- Kelvin Park—sports picnics community
- Gmart—comic book shop

Name one thing in the area that is unique to this community.

· Artistic and open, comfortable. More [street] art that is not gang related.
 Lots of intersections (6 corners).

What does your community sound like?
If you could describe what you heard/hear?

· Music—salsa. (New neighbors
 complained about music.) Heart break-
 ing. Just because of their privilege, they
 take that away from you.

· Backyard parties—rap/salsa
· Latin music. It's comforting.

What are some familiar smells that let you know that you're close to home?

· Paletero/Elotes (Bell)
· Smell of bread/toast (Pulaski and Fullerton?)

Are there any people in this community that everyone knows? Tell us about them.

· Edward Padilla
· Community action—Logan Square
 Neighborhood Association
· Juan Pablo Herrera
· Lucy Parson-Gonzales. Husband killed
 in Haymarket riots. Started the labor
 unions. We're very political.

· Tamale lady, Pulaski and Prairie
· Old man selling elotes
· Coquito cart
· Raspas
· Heavenly gelato place
· A lot of family-owned businesses

What are some things that your community is known for?

- Shooting people—violence
- Diversity—Mexican, Puerto Rican, African American, Colombian, Polish, Guatemalan, Ecuadorian
- Walt Disney childhood home
- The boulevards
- Food

How do you feel about how this community has changed over the years?

- There used to be a bakery called Pierre's. There's a Chuck E. Cheese. Local bakery is now storage place for furniture. Pierre's was a huge loss.
- Logan Square is named after a general.
- Multifamily homes converted to single family homes and vice versa.

What would you like to see more of in your community?

- Art
- Grocery stores/corner store
- Places where youth can hang out Not really welcomed at the new coffee shops, etc.
- More representation of black people
- Community meetings giving voice to the people

What do you hope art will do for your community?

- I hope it will show people what Logan Square really is. How it shows ethnicity.
- Spark conversation about injustices, gentrification. Show people different perspectives of other cultures.
- Hope it creates resistance against what's going on (gentrification). Some sort of resistance.
- Logan Square is home to many immigrants not just the home of many hipsters.
- Who the community really belongs to— the black and brown people. We're not going to keep being pushed out.
- Lots of bars. The neighborhood is more than alcohol.
- I feel like Milwaukee is becoming another Division Street in that it's changing.
- I don't feel the gentrification is working.
- Doesn't feel like home
- This conversation makes them feel important.
- Gentrification—it's oppression... Colonization as you have this influx of high- and middle-class who are displacing low- and middle-class people who built Logan Square.
- Heat is going up. Logan Square is not

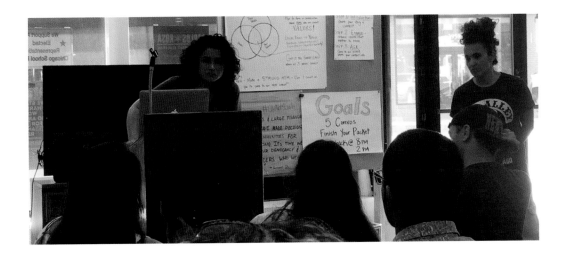

home to me. 606 was made, now there's a bunch of renovations.
· Scares me to see my kind of people are not living the same life style

· Modern day slavery. Mental enslavement. Deteriorating value of culture.
· Feel robbed cuz my culture is not represented

Do you have any fears?

· Slavery, foundation of America. Used to be afraid to speak about it. Realized I need to get my voice out to make change. Speaking out loud about my feelings and thoughts [on slavery and modern-day slavery] helped me be more confident.
· Fear of gang violence
· Older guys catcalling makes me feel unsafe; makes me feel

uncomfortable.
· A lot of shooting; don't feel safe.
· Don't make eye contact.
· Fear of losing family connection through displacement.
Fear of having to move to a different neighborhood.
Having family deported.

Emojis/words that describe Logan Square:

· Sunglasses, fat, rich, full
· Big smile: that feeling after you eat
· Want people to feel safe
· Be who you are
· Diversity
· Super safe
· Passionate
· Fresh neighborhood. Gets lost. A lot to see.

· Something nice to see. Always something going on. Never a dull moment.
· Social movements / activism / adults and teens
· Super progressive. Limitless based on environment ("That's the other side of change").

Public Work

Steven Carrelli

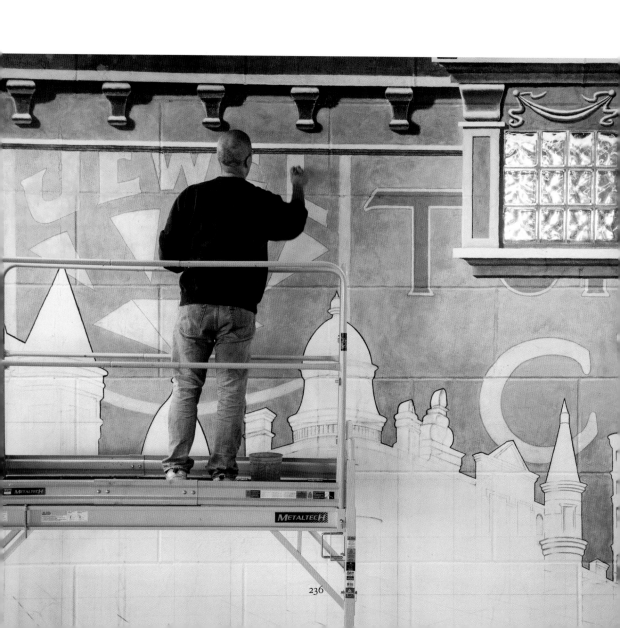

For the past 28 years I've made a career of exhibiting paintings and drawings. Most of my work, though, has been small in scale. In fact, most of it is absolutely tiny. While my work often addresses themes of our relationship to place and history, it usually does so by inviting viewers into a relationship that is intimate and tactile.

I applied to the public art program because I wanted to engage with these ideas in a new way. I was looking for a chance to deal with the specifics of place, history, and identity in a public space. It represented a new challenge, a new chapter, and I was a little afraid of it. I soon learned the location of the wall that I was to paint. The building was a beautiful 19th-century greystone four-flat, but altered as a result of construction on the Armitage Avenue elevated train stop.

In early July, my father died at the age of 86. For me, the loss of my father became inseparable from the birth of the mural. My father was a skilled tradesman, trained as a shoemaker in Italy. For a while he worked at a shoe repair shop in the States, but there wasn't a lot of work for shoemakers here. So, he worked at a brickyard, a loading dock, and he spent over a decade working at the Hoover Vacuum Cleaner plant in North Canton, Ohio. He was used to heavy work, and as a child I used to ask him to flex his biceps and show off his muscled arm. He would oblige me, blowing on his thumb as if to inflate the muscle.

The day after my father's funeral, I met 43rd Ward Alderman Michele Smith, and a committee of community leaders from Chicago's Lincoln Park neighborhood. The stretch of Armitage Avenue where it is located had been designated the Armitage-Halsted Landmark District, and the committee wanted a mural on this wall to celebrate the historic architecture of the neighborhood. They had selected me because they liked the realism of my studio paintings and the precision of my architectural drawings. I researched the neighborhood, sketched ideas, did studies of the architecture. Over a two-week period, I generated a scale rendering of my initial design. At a contentious meeting, the committee rejected the design and asked me to revise it. While some were pleased with it, the most vocal members disliked the liberties I had taken with the historic architecture that they were so proud of. I was, of course, disappointed, but I realized that I needed a genuine way into the subject. How could I both respect the place and contribute something fresh and alive to it?

I walked around the neighborhood some more and read whatever I could find about its history. Then I found my opening. Those ornate buildings with their cast iron pilasters and pressed tin cornices, decorative brickwork and Italianate carved stone window lintels represent a sense of craft familiar to me. Many had been built by immigrant craftspeople: metalsmiths and stonemasons from Germany and Ireland, Italy and Poland. I thought of my parents: a seamstress and a shoemaker who had immigrated to the US from Italy. The people who had built this place had different accents than my parents, but I saw their values and experiences as those of my family. I knew those people, and they were going to be my way in.

I learned that many of the streets in Lincoln Park had once been paved in Nicholson paving: wooden block pavers

covered in pitch and tar and pounded by hand into the ground. I'd grown up seeing that kind of labor, and I'd learned to see it as graceful: a sort of working-class ballet. The gridwork of those pavers—and the labor that they implied—would provide a unifying visual motif linking the ground plane to the architecture— a sort of graphic tapestry—and the windows, pilasters, and moldings would be its warp and weft.

Once the committee approved the design, I began my own version of this labor ballet. The execution of a project like this is not like my usual studio practice. It's more like construction than easel painting: building up and tearing down the scaffold each day, climbing up and down it, scrubbing the thick primer into a thirsty concrete wall with stiff bristle brushes. It's loud and dirty under the 'L' tracks, with trains rumbling overhead every few minutes. It was physical and exhausting.

A mural attracts a public, and the community members quickly became as invested in it as I was. Sandra, the evening station manager, and Janet, the morning station manager, both came out to the wall regularly to check on my progress, and they kept an eye on the mural and my equipment when I wasn't there. Sandra talked with me about her love of calligraphy. Janet greeted nearly everybody on the street by name; she's known as the Mayor of Armitage Avenue. There was Randy at the masonry supply shop, who supplied me with my paints. He took such an interest in my project that he personally delivered two pints of primer to me at the job site. And there was the CTA worker who was painting over graffiti who chatted with me about the design, showed me images of street art that he liked, lent me some tools to fix my scaffold, and gave me a spare drop cloth. People stopped to watch, and many asked questions. Who were we? What were we making? Who was paying for this? Was the city involved? The Alderman?

I finished the mural on a Saturday in October, after about six weeks of painting under the tracks and almost four months after that initial email. It felt quiet. Except, of course, the trains were still rumbling overhead, and the traffic din was constant. A few people honked their horns and gave me a thumbs up, and the usual pedestrians and CTA staff stopped to comment.

At the end of a public project, the artist leaves and the public stays. I called it my wall, but it's theirs. Sandra and Janet are still there every day, and so are Alderman Smith and the ward residents who argued with me about it. The CTA passengers pass it on their way to work and again on their way home. Kids on the way to music lessons walk by it with their parents and point.

On November 9th, my 50th birthday, we held a public dedication. There was a ribbon-cutting with Alderman Smith. The community leaders were there, along with representatives of DCASE and the CTA, my friends and colleagues, my wife, my in-laws, my mother, and my brother. There were speeches and pictures, drinks and doughnuts. It was cold and loud. There was traffic and the noise of the trains. There was the new mural at the east end of the plaza. And at the center, there was the public.◆

Excerpted from "Public Work," by Steven Carrelli, originally published in *Chicago Quarterly Review* 27 (2018).

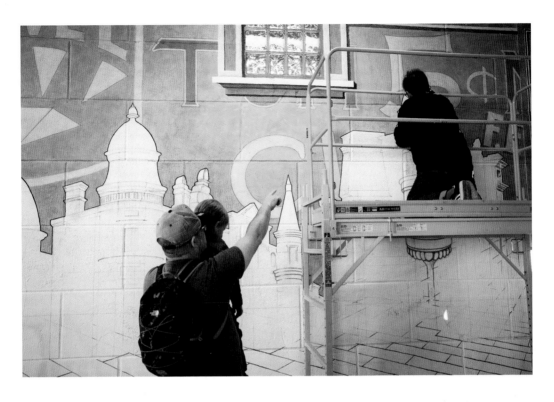

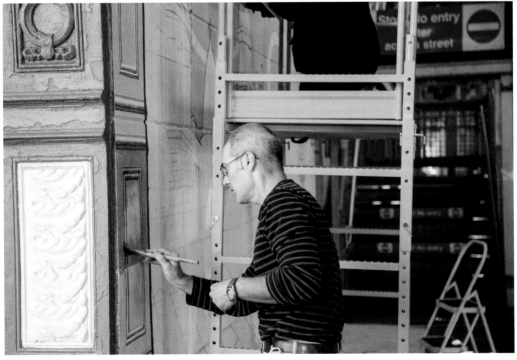

Interview

50x50 Curators

Tricia Van Eck: Can you explain how *50x50* came about?

Erin Harkey: Designated as the Year of Public Art by Mayor Rahm Emanuel, 2017 was the 50th anniversary of two historic works of public art in Chicago: the Chicago Picasso and the Wall of Respect—that is one "50." The other "50" is a celebration and extension of that legacy and history of public art to all 50 wards of the city of Chicago. The *50x50 Neighborhood Arts Project* was a direct opportunity for artists and communities to participate in the Year of Public Art. It evolved into a much larger collaboration with local chambers of commerce and other commisioning agencies, like the Chicago Park District and Chicago Transit Authority (CTA), making this truly a citywide effort and celebration of public art in Chicago.

TVE: What was the selection process?

Joanna Goebel: Artists were selected in different ways depending on the nature of each project. For the *Neighborhood Arts Project*, we began by posting a request for artists' qualifications. We received over 300 responses to the RFQ, and prequalified over 200 of these applicants for consideration for commission by Aldermen. The prequalified artists list was not only used by us in the administration of the *Neighborhood Arts Project*, but was also used by other organizations to develop projects throughout the year. The CTA commissioned artists for their Lightbox Art Project and the Lakeview Chamber of Commerce chose an artist from the list to create a mural.

TVE: How did you encourage the artists', Aldermen's, and neighborhoods' involvement in the project?

JG: In introducing projects to the Aldermen, we gave them guidelines for developing selection panels. Some made direct selections based on the list, others consulted us for recommendations, but a number of Aldermen organized community-based committees and interviewed artists. It was nice to see communities find their own way.

TVE: Why the initiative of community engagement? Why not just give grant money to artists directly through your standard granting channels?

Daniel Schulman: This is a different sort of project that required careful coordination between multiple stakeholders and constituent groups. We wanted the Wards, the Aldermen, and the artists to create public art together. It was important to create a structure where communities and artists could use DCASE as a resource in helping to navigate those relationships.

TVE: Why be public facing? Why public? Why neighborhoods?

Greg Lunceford: Artists live and work in these communities. At its best, the artwork generated through these collaborations can become a part of the community fabric. We can use these conversations between artists and neighborhoods as a way to build and continue a dialogue about how to support artists and communities at the same time.

TVE: Can you talk about the impact that you've seen so far?

Nathan Mason: People want to see this continue. A number of Aldermen have already reached out, excited about thinking about next year. Part of our job is to develop a roadmap of how to continue to build and create interesting, diverse projects throughout all of Chicago's 50 wards.

TVE: What do you suggest are some tools of engagement for public art?

DS: There are many things that serve as inspiration, of which art is just a part. Being sensitive to how inspiration and true engagement manifests on different levels and in different ways for different people is important.

TVE: What do you see as the next evolution? Could this be something you could pass on to another city?

NM: This project is very complex. It has shown the need for developing working relationships, support structures, and guidelines to make sure that this sort of thing can support itself. With that in mind, any city with a commitment to public art could support artists working in multiple neighborhoods at the same time.◆

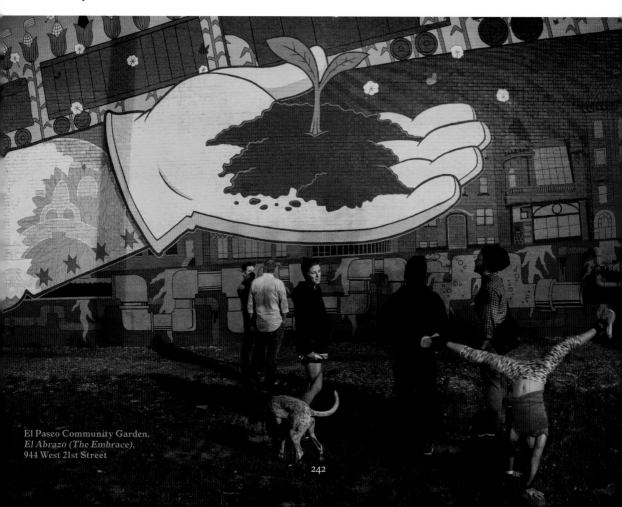

El Paseo Community Garden,
El Abrazo (The Embrace),
944 West 21st Street

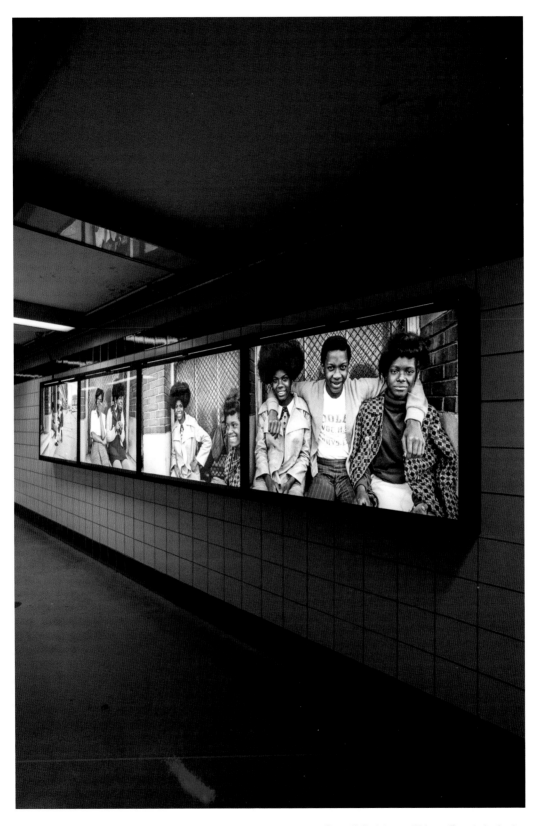

Dorrell Creightney, Chicago Transit Authority,
Central Green Line Station, 350 North Central Avenue

Acknowledgements

A project of this magnitude could not have been realized without the important contributions of key individuals, organizations, and communities. First and foremost, we thank the artists for bringing their bold vision, creative talent, and hard work to enhance and activate neighborhoods across Chicago. We also thank the writers and photographers for beautifully capturing these works. Finally we extend our thanks to the Aldermen, their staff, and their Ward and community organizations for bringing together neighbors, students, teachers, businesses, and volunteers, who collaborated to realize this unprecedented citywide project.

The artists and DCASE wish to extend special thanks to these individuals, organizations, and groups for their assistance:

Robert Abott, Antonio Acevedo, Paula Acevedo, Dan Agosto, Natalie Alicea, Sandra Alvarez, Stella Anderson, Tatsu Aoki, Natalie Aparicio, Marlena Ascher, Matthew Baron, Andrea Bauer, Emmy Bean, Taykhoom Saifuddin Bivji, Nora Blakely, Nick Bojko, Roshonda Booker, Anton Bruckner, Aiyana Buchanan, Jane and Glenn Bullock, Maria Burbano, Craig Chico, Allyson Coglianese, Orbert Davis, William Decero, Mike Dimitroff, Jim Duignan, Ron Duplack, Paul Durica, Kahil El'Zabar, Kelly Fitzgerald, Eileen Fogerty, Lindsey French, Barry Gaby, Bryan Gallardo, Eduardo Garza, Jane Georges, Elliana Given, Jerry Goodman, Lindsey Grace, David Green, Brian Hampton, Wendy Jo Harmston, Amanda Harth, Ron Henderson, Mayra Hernandez, Ralph Hoffman, Yazmin Jiminez, Elizabeth Kelley, Fr. David Kelly, Katinka Kleijn, Manwah Lee, Serina Li, Donna Liette, Joe Madura, Kiam Marcelo Junio, Amber Marsh, Jasmin Martinez, John McDonough, Meida McNeal, Stormie McNeal, Greg Michie, Ewelina Mikocewicz, Joseph Mora, Enrique Morales, Melissa Musseau, Julio Chikawaukaltzin Nieto, Carma Lynn Park, Grace Pisula, Dan Pogorzelski, Karen Pogorzelski, Zoe Prell, Darrell Pulliam, Madeline Rabb, Gina Ramirez, Lee Ravenscroft, José Rios, Joseph Rios, Diana Rubio, Tom Schmidt, Chema Skandal, Edra Soto, Jason Steger, Dave Smykowski Stone, Yu Su, Maureen Sullivan, Jiaming Sun, Brigitte Swenson, Martha Tellez, Jocelyn Tlapa, Howard Tullman, Lilly Tully, Quinn Turley, Rocio Varela, Linda Vidmar, Christy Webber, Karen Widi, Ernie Wong, Ji Yang, and Avery R. Young.

11th Ward Veterans, 37th Ward Aldermanic Office, 48th Ward Art Committee, After School Matters, After School Matters Orchestra, Air America Aerial, Air Force Academy High School Choir, AJ Antunes & Co., Arts Alive Chicago, Associates Landscaping, Austin Coming Together, Back of the Yards Coffeehouse and Roastery, The Back of the Yards Neighborhood Council, Bounce for Joy Project (BFJP), Charles R. Henderson Elementary School, Chicago Children's Choir, Chicago Department of Aviation, Chicago Department of Fleet and Facility Management (2FM), Chicago Department of Transportation's Make Way for People, Chicago Event Graphics, Chicago Ice Works, Chicago Neighborhood Initiatives, Chicago Park District, Chicago Park District, Kilbourn Park, Chicago Park District's Night Out in the Parks, Chicago Police Department, Chicago Public Library, Chicago Sculpture International, Chicago Transit Authority (CTA), Chicago Tree Project, Christy Webber Landscapes, Civilian Office of Police Accountability (COPA), ComEd's Solar Spotlight Program, Cook County Juvenile Detention Center, David Zwirner Gallery, Department of Planning and Development's Retail Thrive Zone Initiative, Fellowship House of Chicago, Fifield Companies, For Freedoms 50 State Initiative, Friends of Kilbourn Park Organic Greenhouse, Gaby Iron, Greater West Town Partnerships, HairPin Arts, Historic Pullman Foundation, The Howard Brown Health Center, I Grow Chicago, Illinois Institute of Technology's Master of Landscape Architecture program students, Iron and Wire, James Ward Elementary School, Jesse Brown VA Medical Center, JC Licht / Benjamin Moore, Kilbourn Park staff and Advisory Council, Lolly Extract, LSNA, Metra, Murals of Acceptance, National Museum of Mexican Art, National Park Service, North Lawndale Employment Network, The North River Commission, Northalsted Business Alliance, Palmisano PAC, Peace & Education Coalition, Philip D. Armour Elementary

School, Phoenix Military Academy High School, Pilsen PERRO, Port Ministries, Precious Blood Ministry of Reconciliation, The Puerto Rican Cultural Center, The Pullman Civic Organization, PullmanArts, Roberto Clemente Community Academy, Schurz High School, Segundo Ruiz Belvis Cultural Center, Sherwin Williams Company, Silent Funny, Skidmore, Owings & Merrill LLP archival collection, SkyART, Stroger Hospital, Uptown Bikes, Voices for Children, West Pullman Park Cultural Center, West Ridge Nature Preserve, West Town Chamber of Commerce, William H. Seward Communication Arts Academy Elementary, William H. Wells Community Academy High School, Willowbrook Wildlife Center, Workingbikes.org, and Yollocalli Art Reach.

Chicago Department of Cultural Affairs and Special Events
Mark Kelly, Commissioner
Lisa Laws, First Deputy Commissioner
Miriam Gutierrez, Deputy Commissioner of Finance
Erin Harkey, Deputy Commissioner of Programming
Ann Hickey, Deputy Commissioner of Facilities
Jennifer Johnson Washington, Director of Special Events
Jamey Lundblad, Chief Marketing Officer

Public Art Program contributors
Susan Friel, Education and Engagement/
 Visitor Experience
Joanna Goebel, Curator of Public Art
Greg Lunceford, Curator of Exhibitions
Nathan Mason, Curator of Exhibits and Public Art
Daniel Schulman, Director of Visual Art

Year of Public Art guest curators
Miguel Aguilar
Janice Bond
Tricia Van Eck

Lead designers
Jason Pickleman & Mia Hopkins,
 JNL Graphic Design

Editor
Tricia Van Eck, 6018North

Co-Editor
Iker Gil

Essayists
Abdul Alkalimat
Romi Crawford
Eric Keune
Rebecca Zorach

Writers
Joe Madura
Nathan Albhalter Smith
Tricia Van Eck

Copy Editors
Michelle Benoit
Kathryn Kruse

Photographers
Jasmine Clark
Ji Yang

Videographer
Ji Yang

Additional Photographers
Antonio Acevedo p. 119
Alberto Aguilar p. 78
Eric Anderson p. 49
Architreasures p. 44–45
Jasmine Clark p. 36–38, 40–41, 90–91, 98–99, 103, 108–111, 114–117, 137, 142–143, 151, 160–163, 168–171, 172, 178–179, 192–193, 194–197, 204–207, 208–209, 233, 243
Darryl Cowherd p. 25
Katherine Darnstadt p. 88–89
Annette Elliot p. 190–191
Fugie p. 118
Dillon Goodson p. 200–201, 210–211
Barbara Karant p. 154
Jenny Kendler p. 46, 48–49
Kirsten Leenaars p. 81–83
Davis McCarty p. 222–223
Jessie Meredith p. 54–55, 112–113, 132–135, 174–176, 213, 224–225
Northwest Arts Connection p. 137–138
Erik Peterson p. 212, 214–215
Cheryl Pope p. 218
Patrick Pyszka p. 141, 180–181
Dave Rader p. 146–148
Edwin Ruiz p. 4, 122–125
Robert Sengstacke p. 20
Cyd Smillie p. 164–165
Sandra Steinbrecher p. 182–185
Ezra Stoller © Esto photo courtesy of SOM Unveiling, ©2018 Estate of Pablo Picasso / Artists Rights Society (ARS), NY p. 15, 17–19
Tricia Van Eck p. 139, 140, 173, 231, 235
Ji Yang p. 2–3, 32–35, 42–43, 50–53, 56–73, 79, 84–87, 92–93, 94–97, 100–102, 104–107, 120–121, 126–128, 130–131, 144–145, 150, 152–153, 156–157, 166–167, 186, 188–189, 199, 216–217, 219, 220–221, 226–227, 229, 236, 239, 242, 248
Bernard Williams p. 202–203

Index of Artists' Names

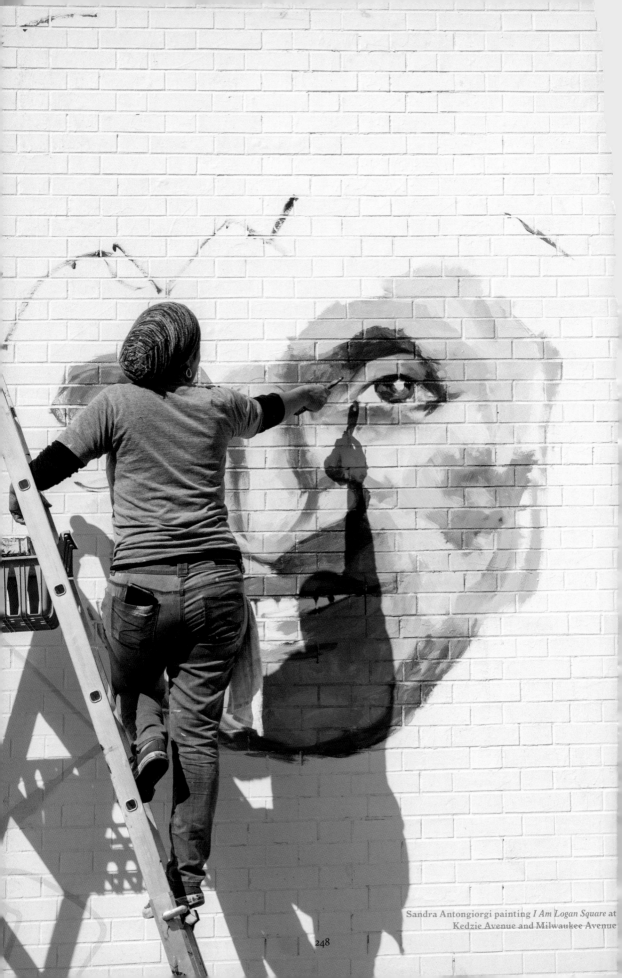

Sandra Antongiorgi painting *I Am Logan Square* at
Kedzie Avenue and Milwaukee Avenue